MURRAY L. PETERS

# WHOOP'S APOSTROPHE....!
## #7

authorHOUSE

*AuthorHouse™ UK*
*1663 Liberty Drive*
*Bloomington, IN 47403 USA*
*www.authorhouse.co.uk*
*Phone: 0800.197.4150*

© *2018 Murray L. Peters. All rights reserved.*

*No part of this book may be reproduced, stored in a retrieval system, or transmitted by any means without the written permission of the author.*

*Published by AuthorHouse 04/28/2018*

*ISBN: 978-1-5462-9218-0 (sc)*
*ISBN: 978-1-5462-9219-7 (e)*

*Print information available on the last page.*

*Any people depicted in stock imagery provided by Getty Images are models, and such images are being used for illustrative purposes only.*
*Certain stock imagery © Getty Images.*

*This book is printed on acid-free paper.*

*Because of the dynamic nature of the Internet, any web addresses or links contained in this book may have changed since publication and may no longer be valid. The views expressed in this work are solely those of the author and do not necessarily reflect the views of the publisher, and the publisher hereby disclaims any responsibility for them.*

# DEDICATION

To Mr. Andrew Ward!

My first APT English in my teaching 'career'; my Probationary mentor; the best Staff Football Team Left Back in the world, and always there for the 5s!

He coined a phrase that has stuck with me always - "Anything that you'd like to tell me, son?" as he'd peer out a narrow window section of his perpendicularly-along classroom, in my early days of using Corporal Punishment (the tawse) - on the odd unfortunate, but deserved, recipient!

A jocular phrase of course, but concerned always, as in did I need to divulge circumstances / need his help... My hero.

"They thought it was all over. It is now!" This IS the LAST one, seriously!!

Everyone from now on a daily basis but only via Twitter + Facebook!

Got an English teacher in your family or who you like...BUY this (or 'WHOOP'S APOSTROPHE...! #1-6) via authorhouse.com OR peterlmurray@hotmail.co.uk

And all of this just so as you know when & where to put it in and when & where not to!!

I'm sure all of your English teachers said... "If in doubt, leave it out!!"

BUY! LOOK/READ! ENJOY! LAUGH! SHOW! TELL! SHARE!

BUY THEM...for...DOCTORS' & DENTISTS' (ra Waiting Rooms obvs.!) & erm Hospitals (Waiting Areas & Patients).

For 'PLANES, TRAINS & AUTOMOBILES'?! For your erm FACILITIES @home!?! BUY THEM for... your Local CAFE / SNACK BAR? For your... GRANDPARENTS - they'll remember what they are!! CARE HOMES?! HOTEL FOYERS!!

AN (intelligent) CELEBRITIES' (neat oxymoron!) QUIZ SHOW?!!

*PERFECTLY IMPERFECT PUNCTUATION - PHOTOS by PETER PERFECT*

MURRAY L. PETERS is also the author of a Series of 4 novels - overall title 'BOYLE-BREATH', about a human/alien teacher called Mr. Bernard Boyle, whose Zeronian powers allow him to use human smells, especially their farts, to HELP individuals - especially the bullied AND the bullies, by using his all-powerful mastery of Smell & their individual smell-histories to help, to annoy, to...kill!?!?

Perfumes yes, favourite smells yes, pongs definitely! Mix in everything from Nazi Zombies to Social Workers; Health and Safety to Vampires, oh and Murder!!

"Charming and thought provoking...ingenious plot" Jill Allan (Clarion Press).
'**Breathtaking!**' (The Zeronian Bugle).

# CONTENTS

Dedication .................................................................................. v

Chapter 1: Wrong BUT Fixed ................................................. 1
Chapter 2: Apostrophes ............................................................ 8
Chapter 3: Apostrophes AND Spelling ................................. 54
Chapter 4: Spelling ................................................................ 59
Chapter 5: One Wrong, One Right!! ..................................... 96
Chapter 6 And 7: T.V and Subtitles ..................................... 106
Chapter 8: Sofia 2017 ........................................................... 109
Chapter 9: Fuengirola 2018 .................................................. 112
Chapter 10: Just Weird ......................................................... 120
Chapter 11: MLP ................................................................. 138

# CHAPTER 1

# WRONG BUT FIXED

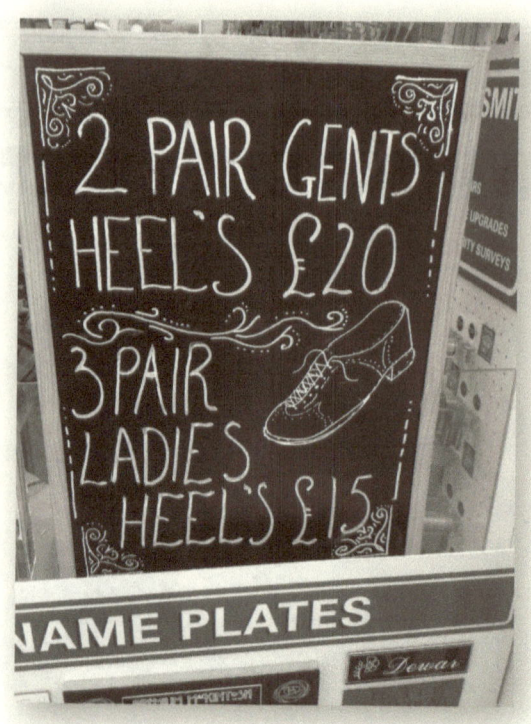

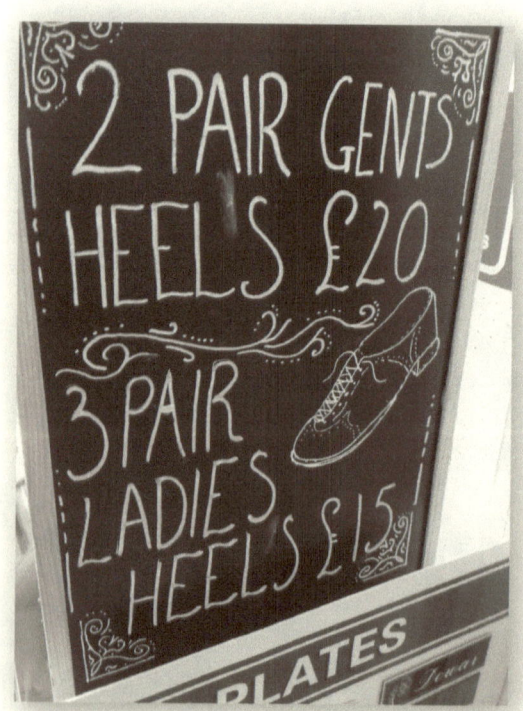

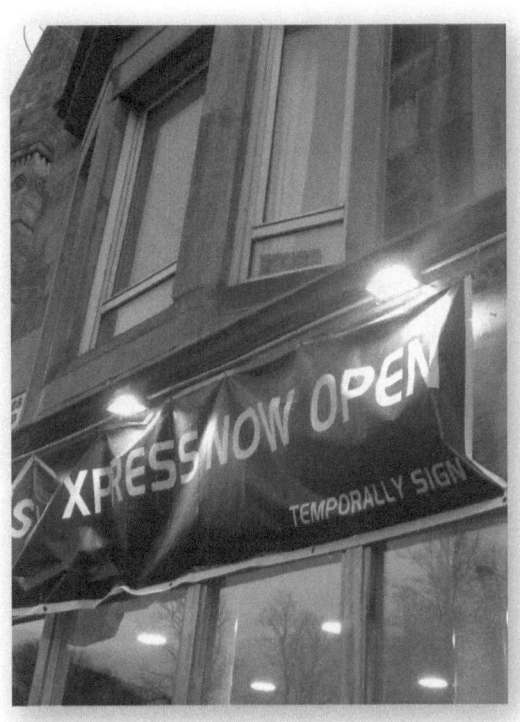

If you are, or think you may be, pregnant please inform your dentist.

Thank you.

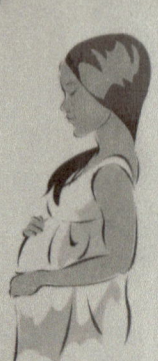

If you are, or think you may be, pregnant please inform your dentist.

Thank you.

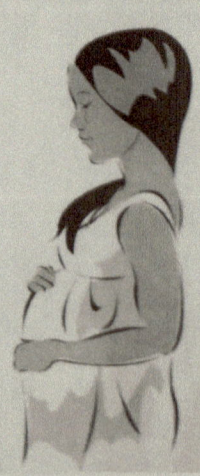

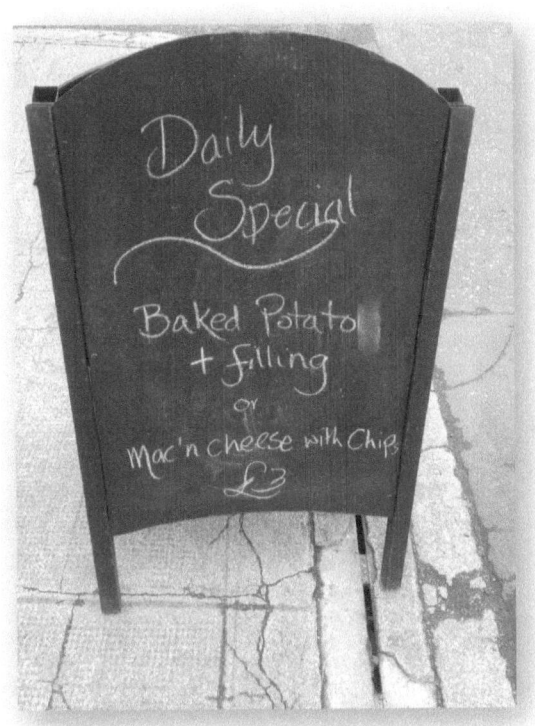

Daily Special

Baked Potato + filling
or
Mac'n cheese with Chips
£3

**Notice To Patients**

**If You Fail To Attend An**

**Appointment Or Do Not**

**Give 24 Hours Notice To Cancel,**

**A Charge Of £15.00 Miniumum Shall Be Applicable.**

# BANNED IMAGES!!

Below are only the WORDS from various IMAGES that were deemed by my own Self-publisher to be Copyright Infringed / T.V. Screen 'Grabs' / Newspaper clippings / Website Screenshots... ENJOY!! (I have been done by 'Big Brother'! '1984' meets 2018!

## From Chapter 1 – FIXED...

I had TV Screen Grabbed "Workers at A Steel PANT" off a TV News channel bottom-of-the-screen 'ticker-tape' Breaking News, it had meant to read 'Workers at A Steel PLANT' of course! (Error was fixed 54mins later

Another T.V. Screen Grab was where I had photographed A T.V. Sports' Channel which had news that they would show the game LIVE between Glasgow Rangers v. Glasgow Celtic but gotten the DAY wrong though the DATE correct! (FIXED the next day!).

## CHAPTER 2

# APOSTROPHES

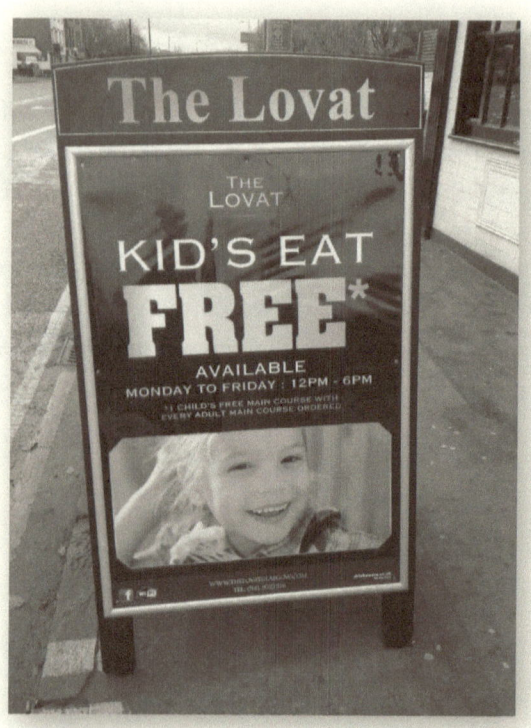

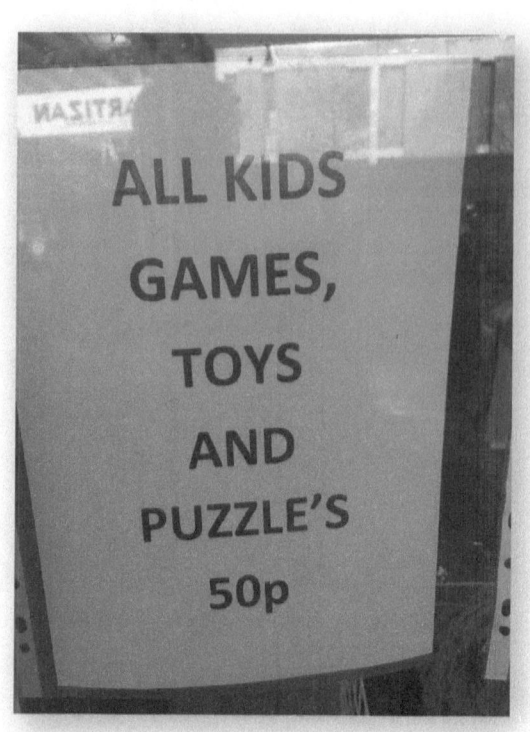
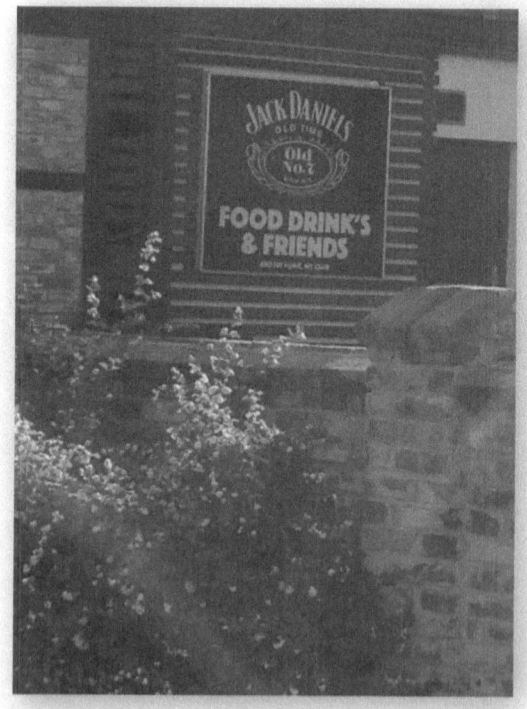

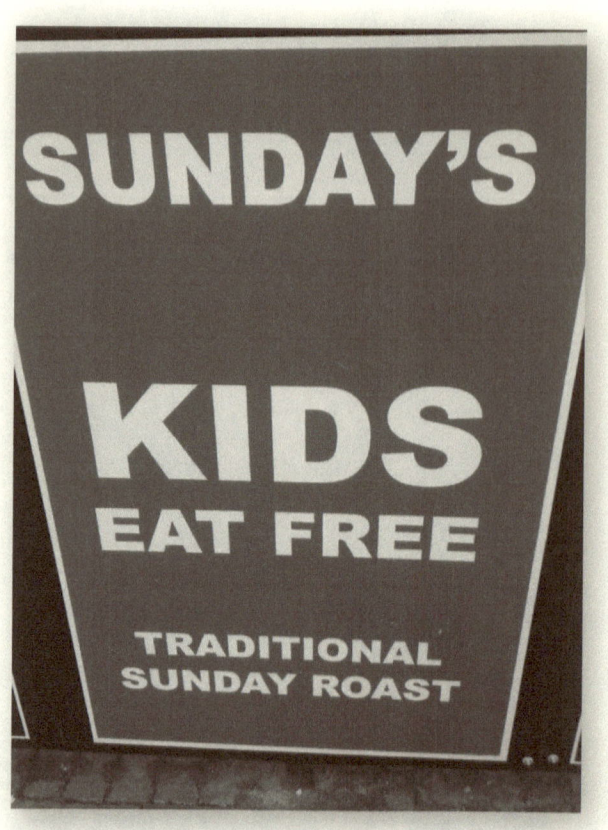

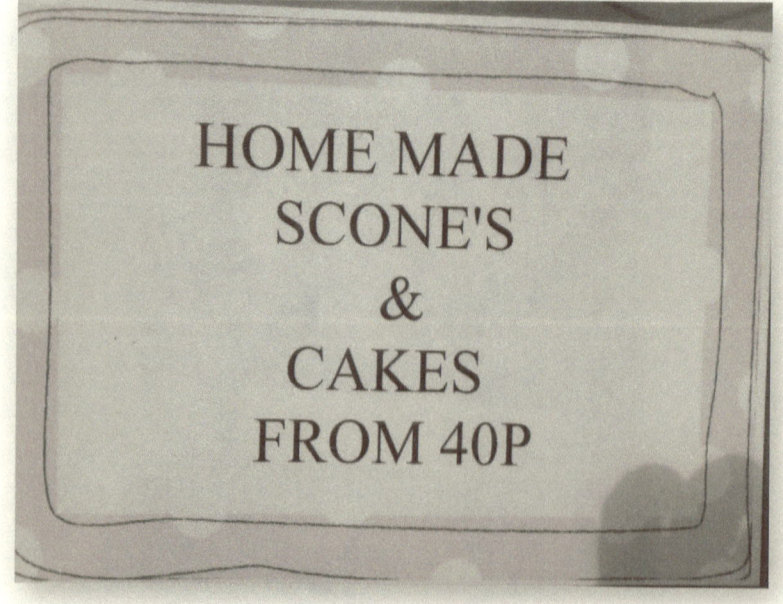

PIE'S 90P
SAUSAGE ROLLS 90P
STEAK PIE'S 1.20
PIZZA 1/2 1.00
FULL PIZZA 2.00

on your birthday, remember...
we've got photo's of you in a
nappy and we're not afraid to
embarrass you with them!

Happy Birthday

# *Introducing*
## OUR NEW MENU'S

## ALL DAY MENU
FROM 12 - 9 PM
EVERY DAY

## QUICK BITE
FROM 12-3 PM
MONDAY TO FRIDAY

## CLIPPER *for the* NIPPER
FROM 12 - 9 PM
AVAILABLE EVERY DAY

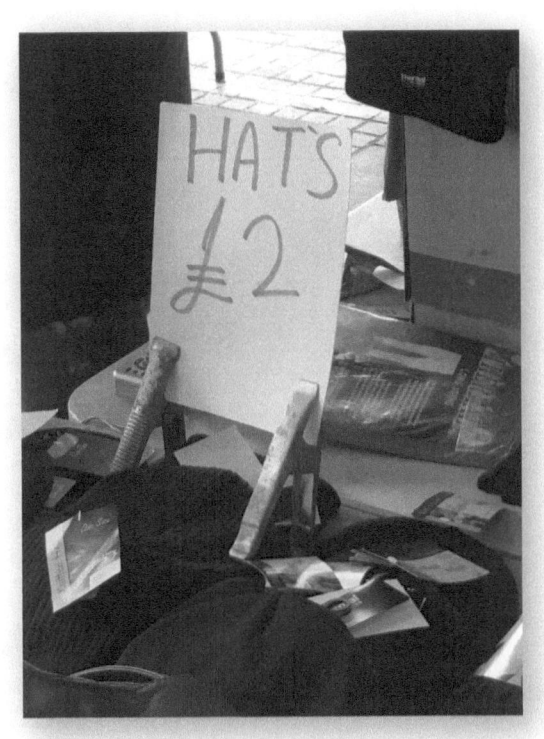

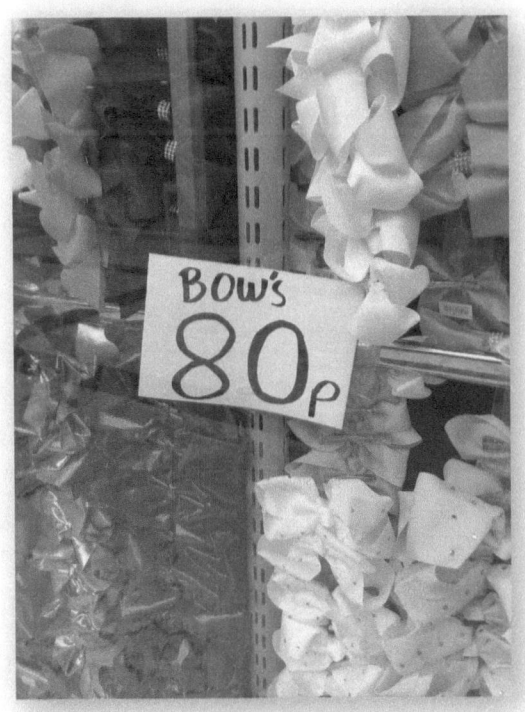

ioie staff team hav
eeks so we can all
🖤🖤👶👶 xoxo

aws, conditions and regulations

d car park and ScotRail, it's staff
contents or accessories however
efault of ScotRail, it's staff or agents
y person except for injury caused

epts them on behalf of all other

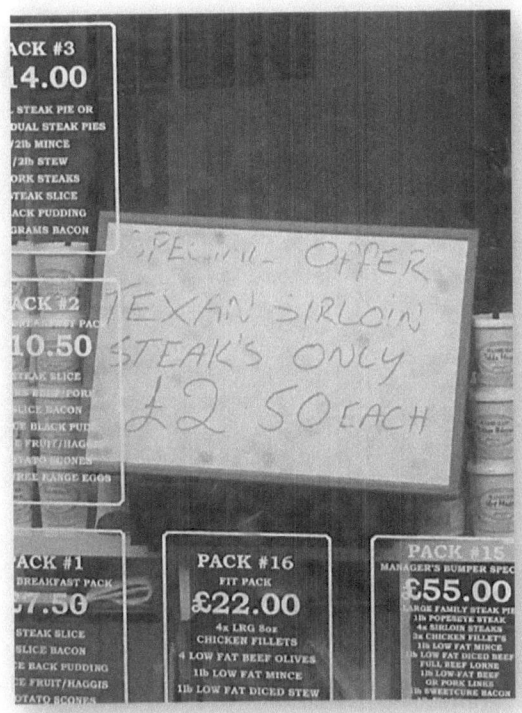

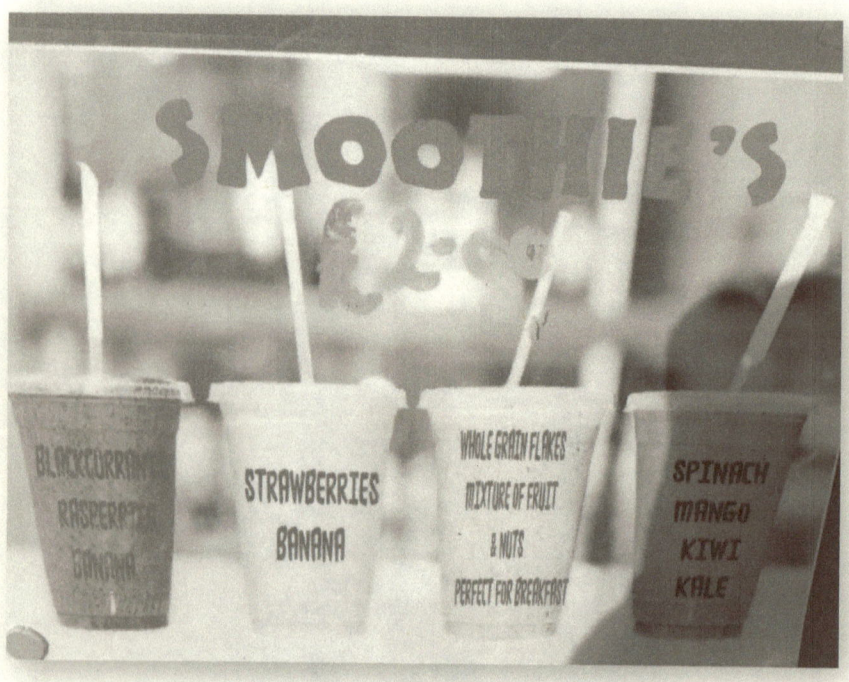

erved with garlic bread

        Bacon, chorizo, red onion or cajun chicke

asta    Its that good it made it on twice!

        Onion, garlic & chilli in a fresh Napoli sauce

        Add bacon or chorizo

        Classic Italian recipe just like "Nonna" used to make it

        Add chicken

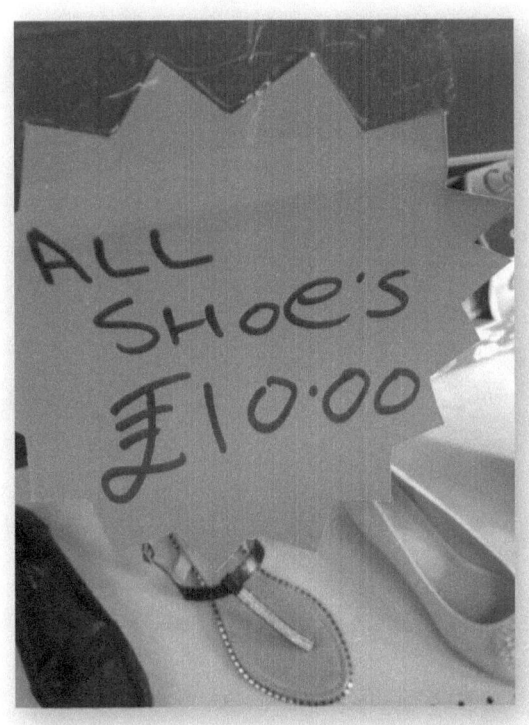

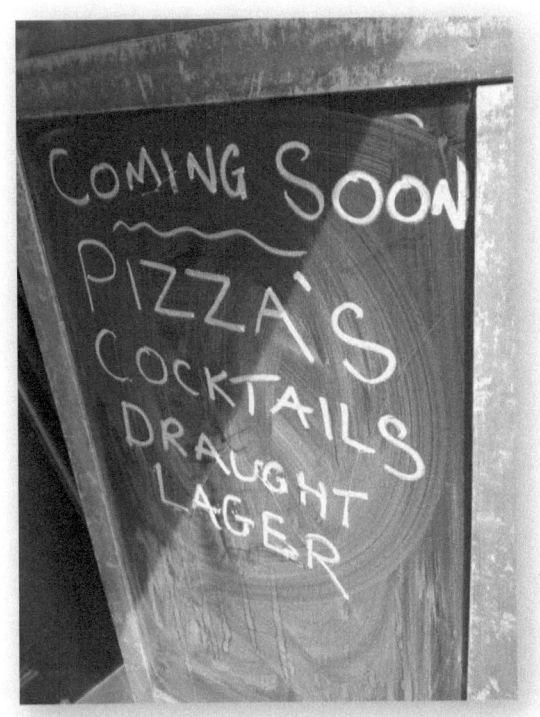
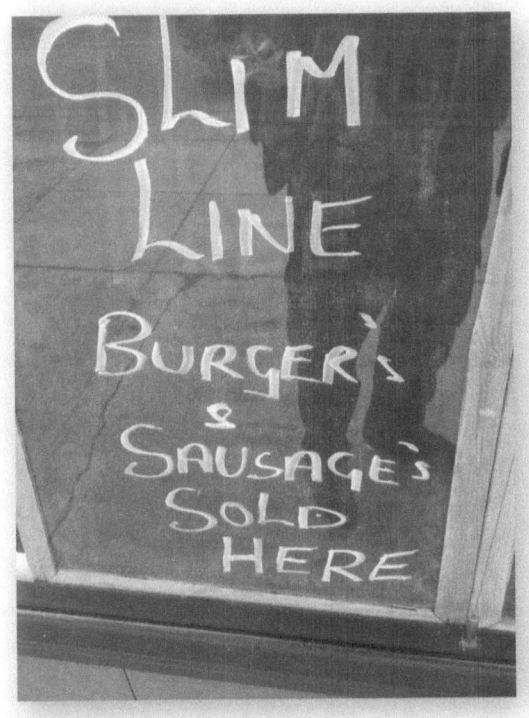

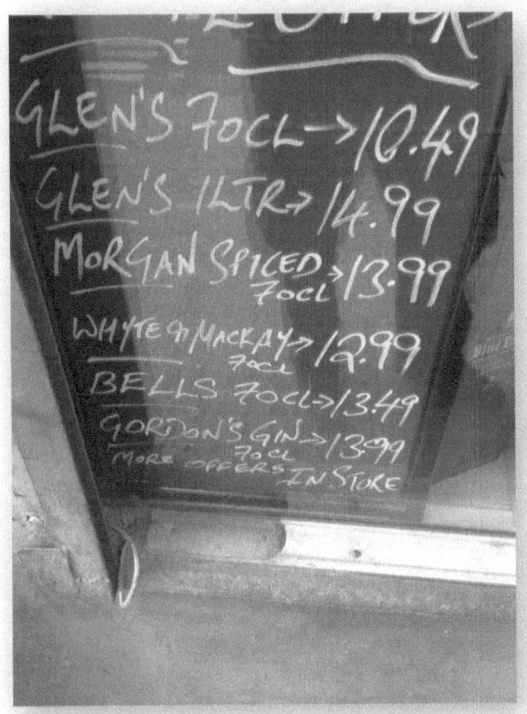

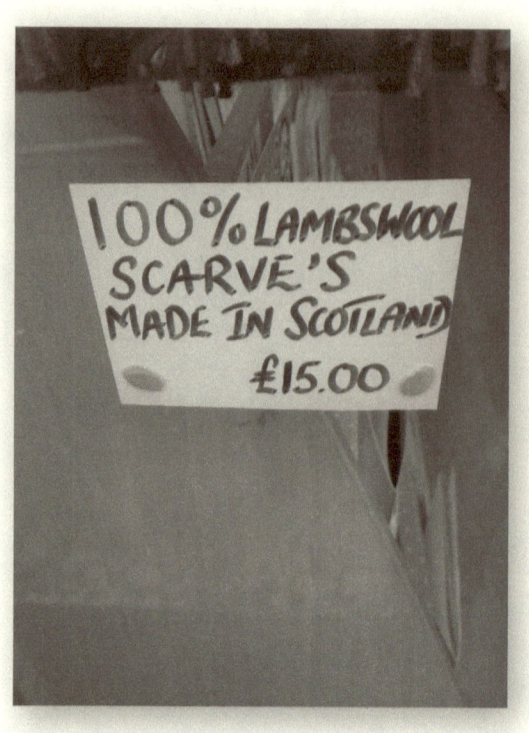

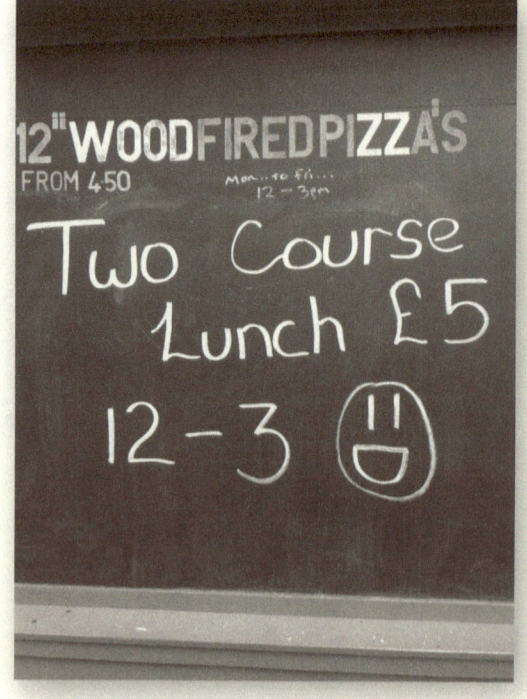

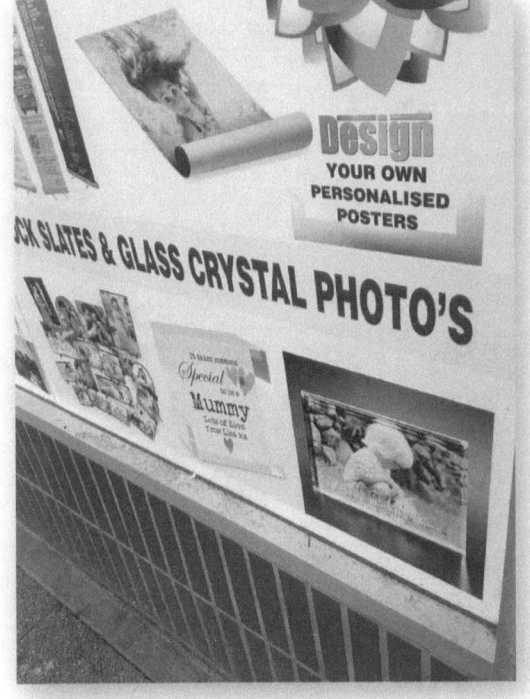

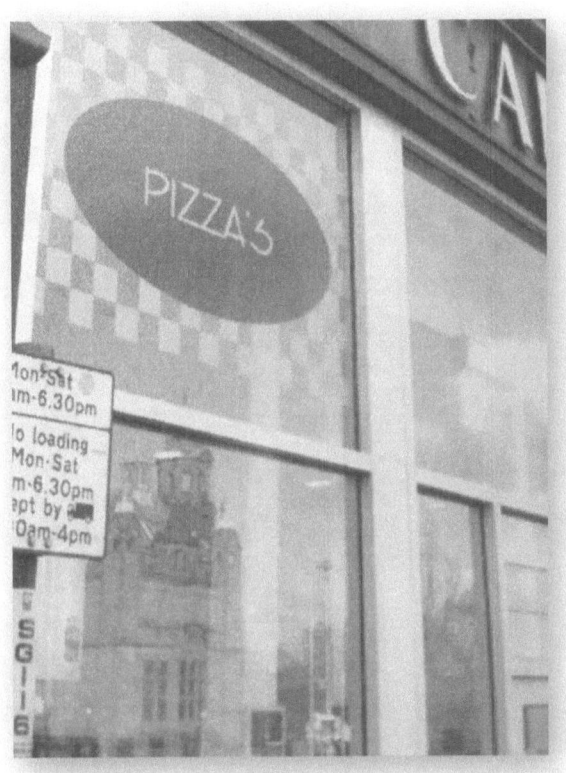

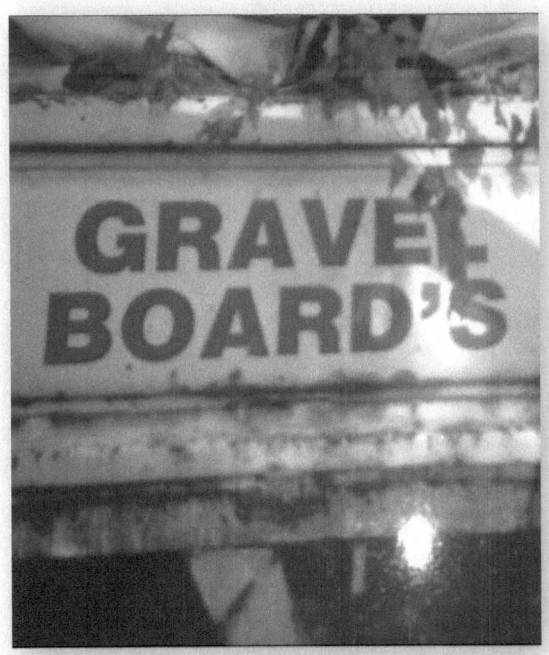

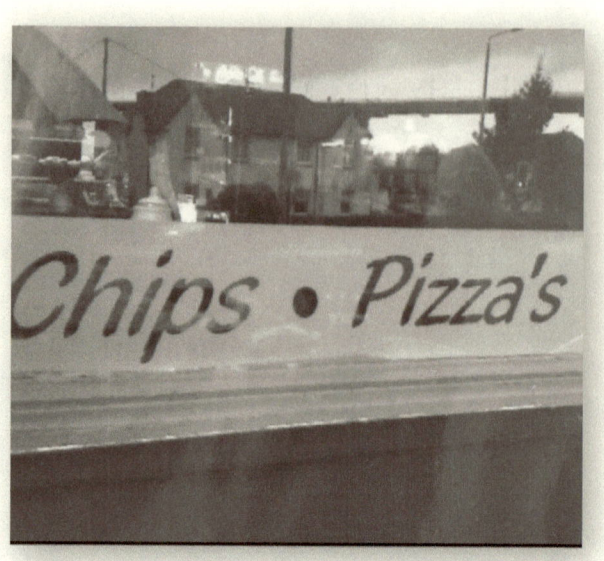

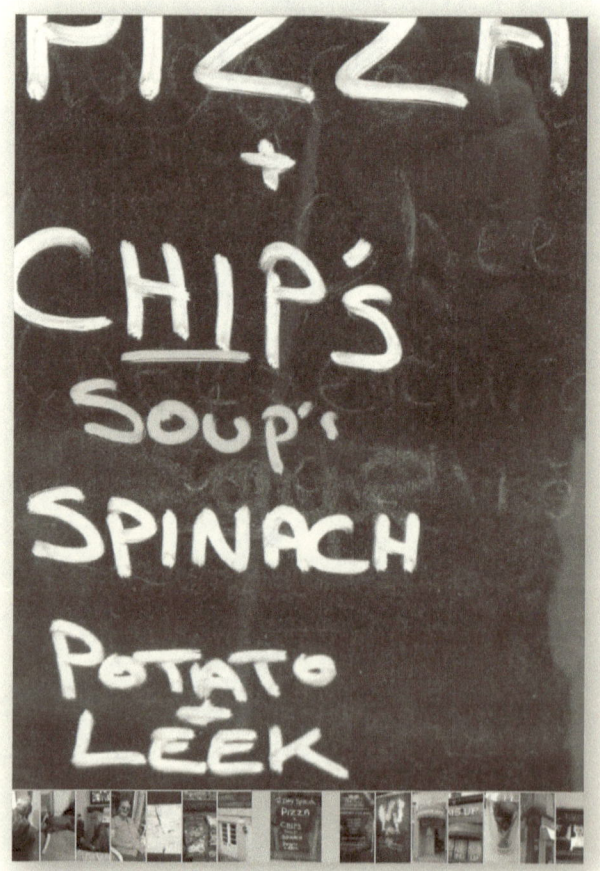

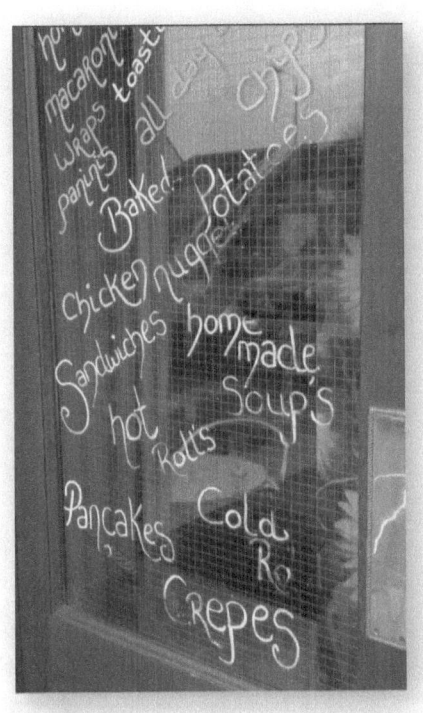

RAY JUST ENERGY
COCKTAIL´S

DDULPH´S V
E mail biddulphsca
- CARPETS
- BLINDS - VINYL'S
- WOOD FLOORING
SUP
FIT
FLOORING
PHONE ALE

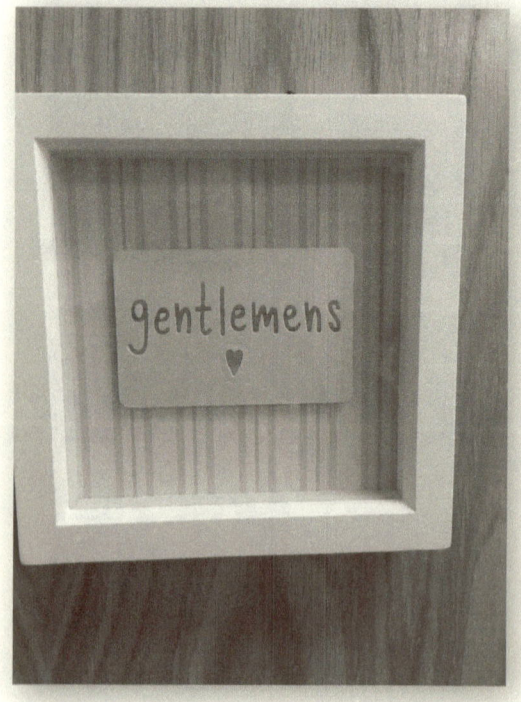

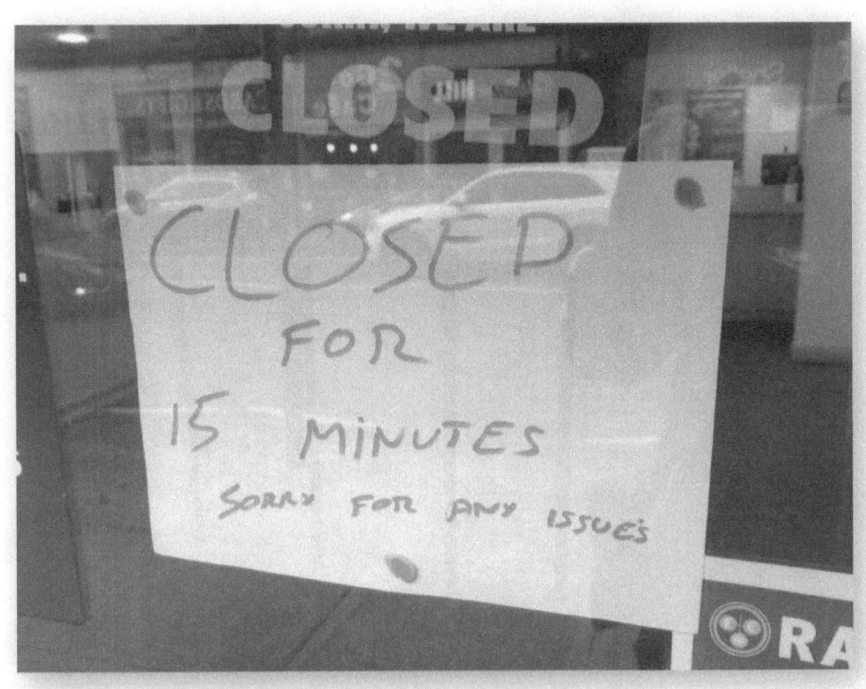

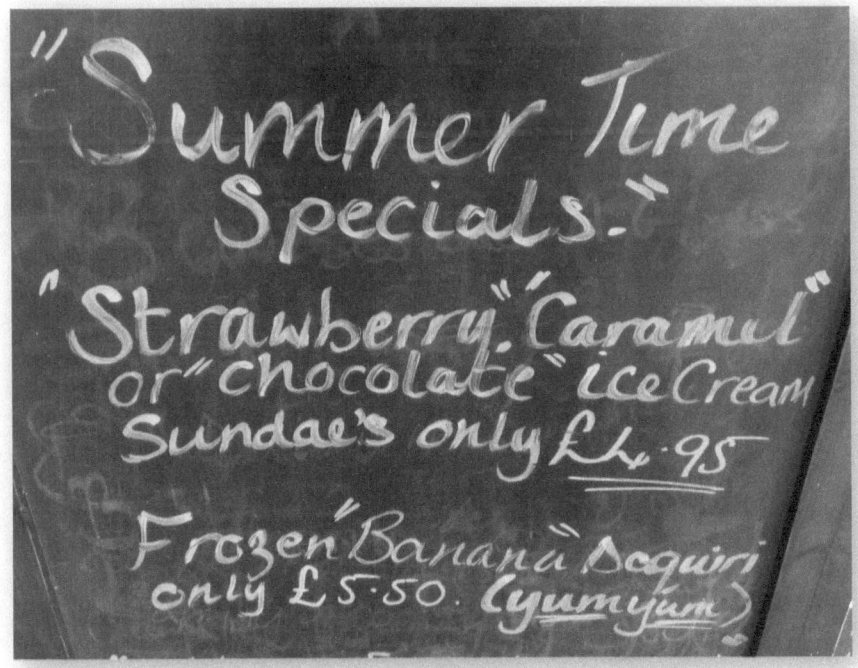

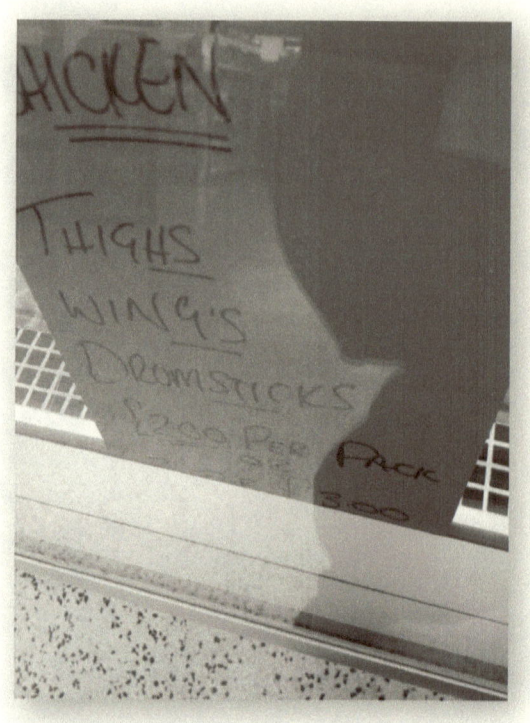

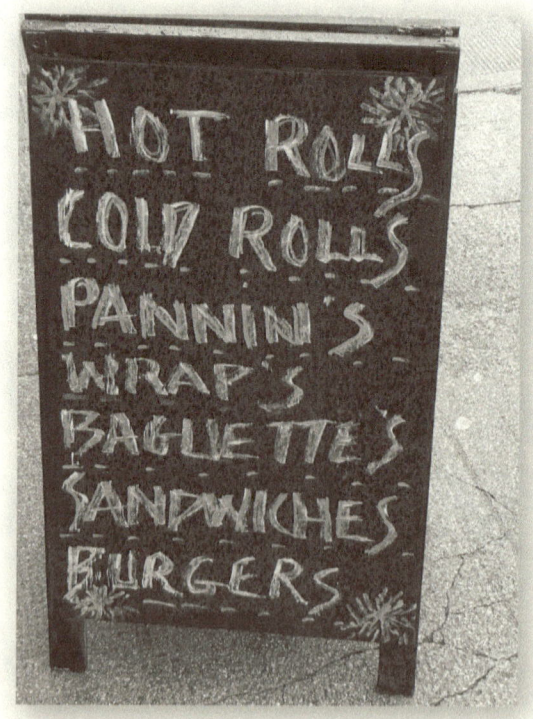

# BANNED IMAGES!!

## From Chapter 2 - Apostrophes...

I had T.V. Screen-grabbed crowds in the middle of Sporting Events where there were people holding up HUGE signs with APOSTROPHE ERRORS!!

One said... "IM A TEACHER" from a crowd watching T.V. Darts.

Another said... "LETS GO ROGER" from out of a crowd watching... Tennis!!!?!

# CHAPTER 3
# APOSTROPHES AND SPELLING

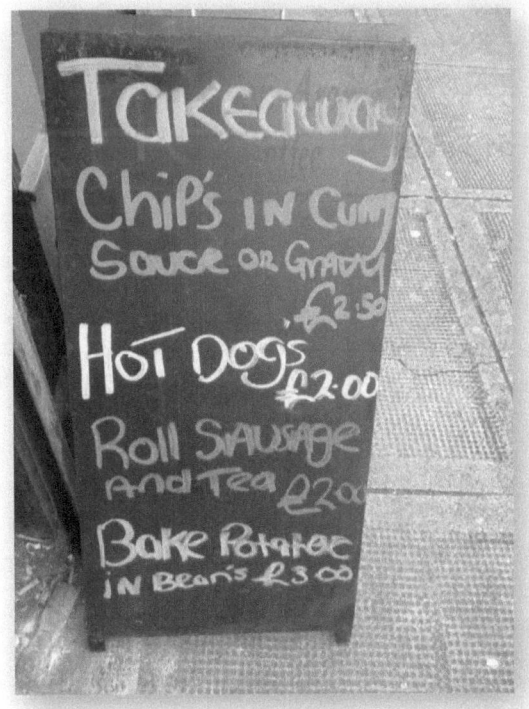

*Murray L. Peters*

# BANNED IMAGES!!

## From Chapter 3 - Apostrophes AND Spelling...

I had an advert for Valentine's Day off of the Internet BANNED.

The firm had NOT used an Ap. so ran it as "VALENTINES NIGHT" & also had written "RECIEVE a complimentary glass of..."

# CHAPTER 4

# SPELLING

> Over the Festive Period we are not able too allow trolleys in as it causes a conjestion in the Restauarnt and for health and safety reasons.

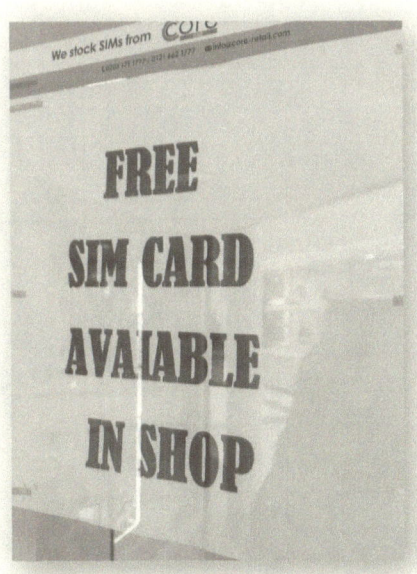

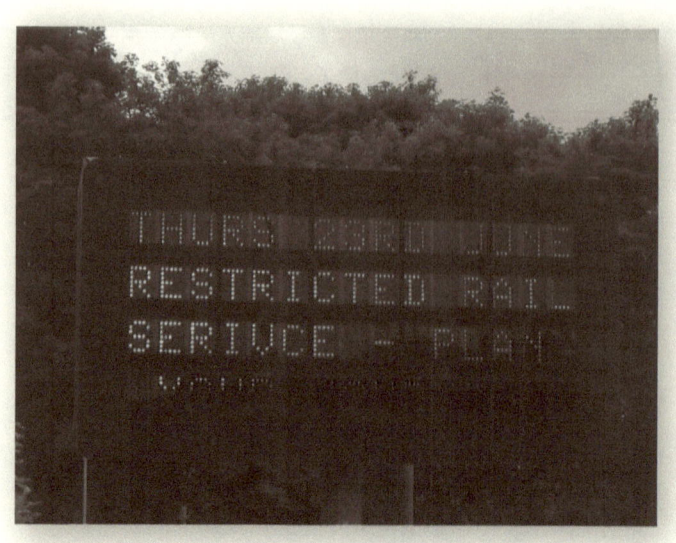

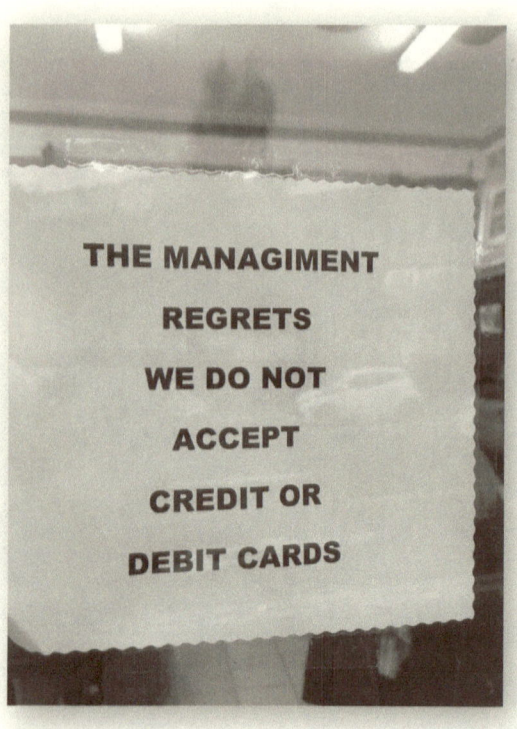

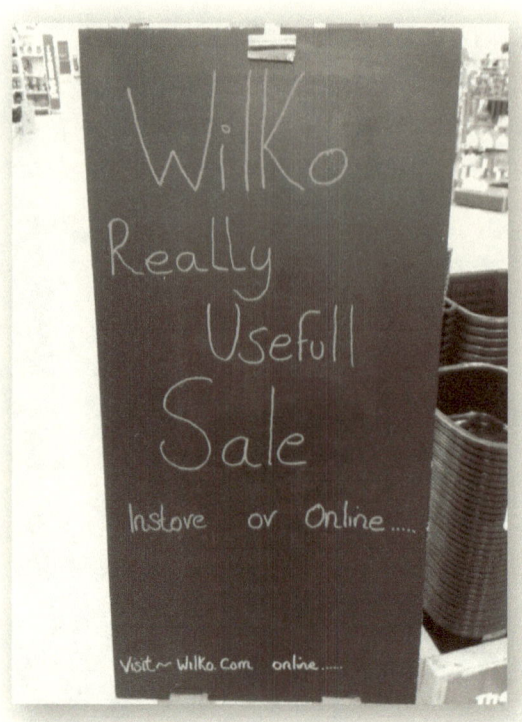

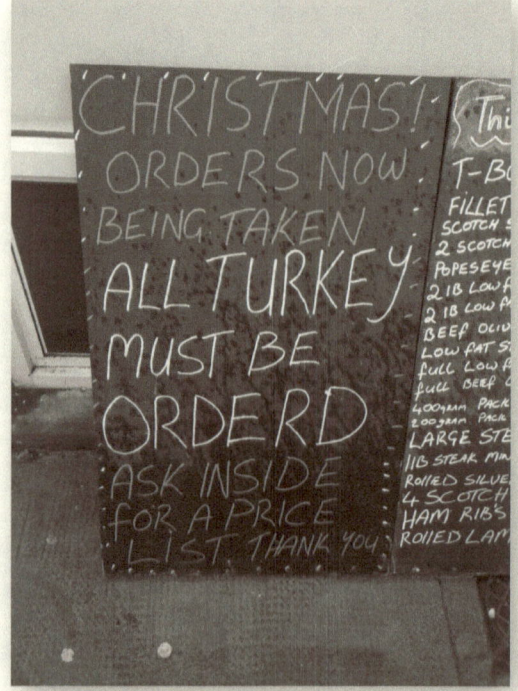

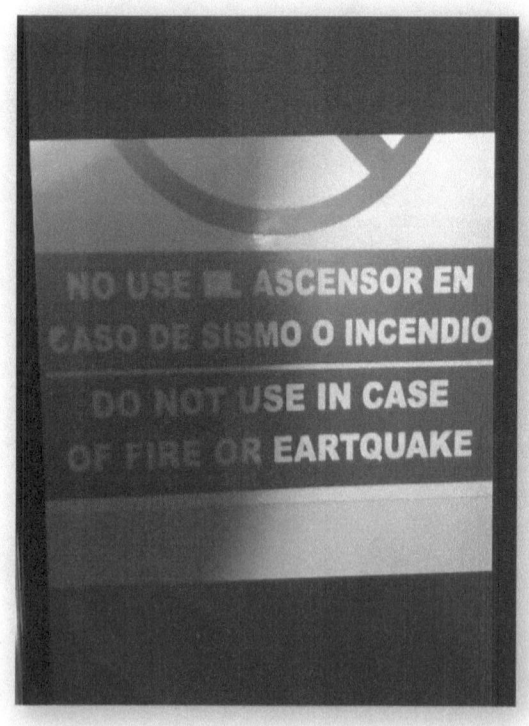

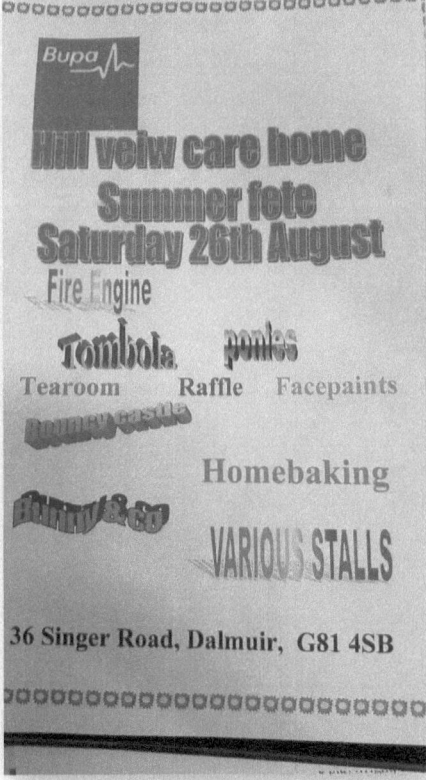

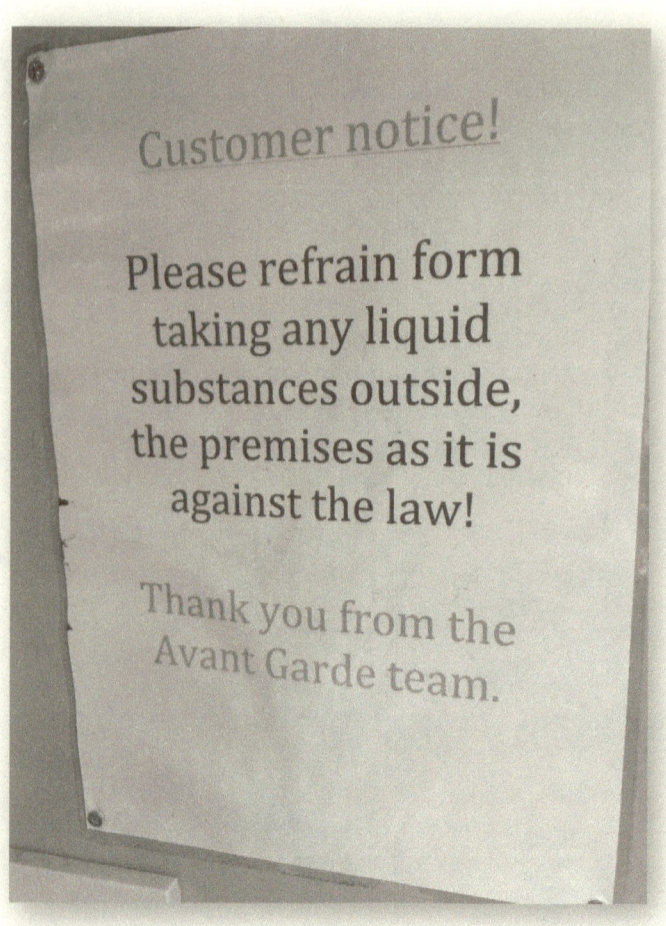

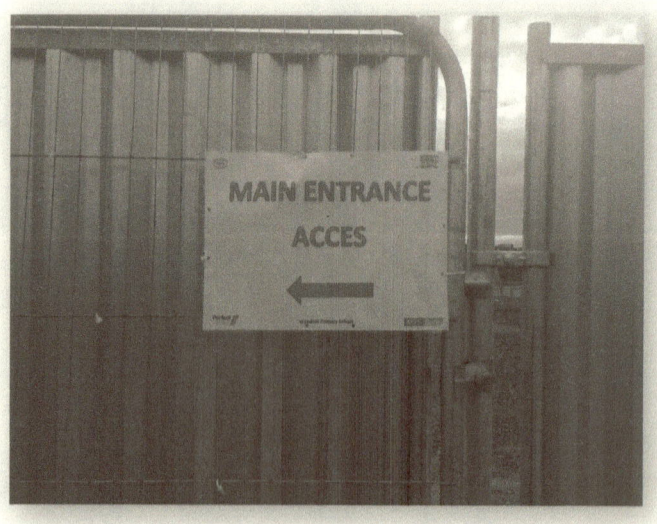

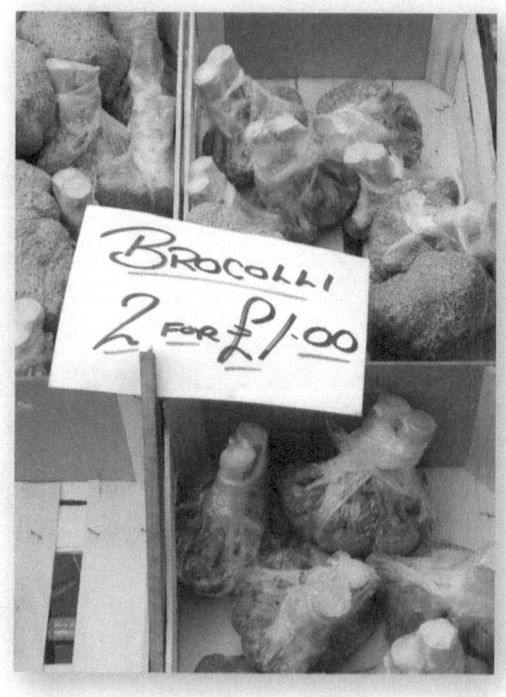

## LUNCH

*AVAILABLE 12-4PM*

SOUP & SANDWICH DEAL £5.95

*SERVED WITH SIDE SALAD AND TORTILLA CHIPS*

TUNA MAYO/ CHEESE & PICKLE/ BLT/ CHICKEN TIKKA

### BAKED POTATOES £6.25

*SERVED WITH SIDE SALAD AND TORTILLA CHIPS*

TUNA MAYO /CHICKEN TIKKA/ CHEESE & PICKL
SUNBLUSHED TOMATO, PEPPER, PESTO & MOZZA
MELT.

### TOASTED WRAPS £7.95

*SERVED WITH SALAD AND SKINNY FRIES*

TUNA MAYO MELT/ SWEET CHILLI CHICKEN MAYO
/MOZZARELLA, TOMATO, PESTO & PEPPER M

We meant to send you something for your retirral. Hope you can find a nice bottle with this.

WITH YOUR CHOICE OF 3 TOPPINGS

DESSERTS
CHOCOLATE & CRANBERRY CHEESECAKE WITH GINGER B[...]
BAILEYS & ORNAGE TIRAMISU
CHRISTMAS PUDDING WITH BRANDY SAUCE
SELECTION OF ICE CREAM
[A]PPLE & CINNAMON CRUMBLE WITH VANILLA ICE C[...]
CHEESE BOARD

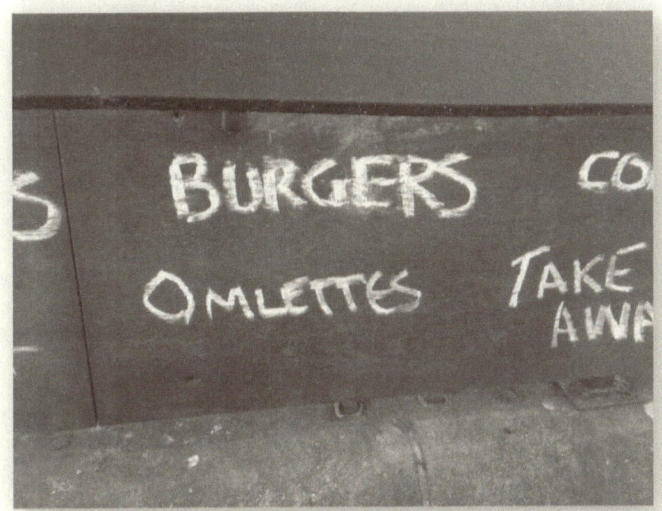

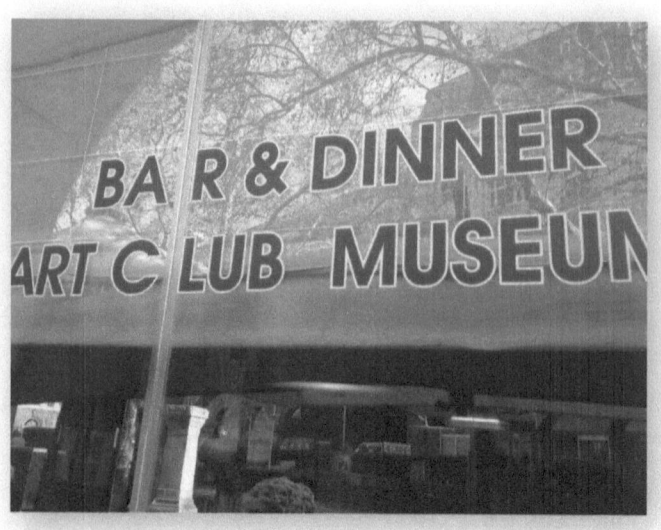

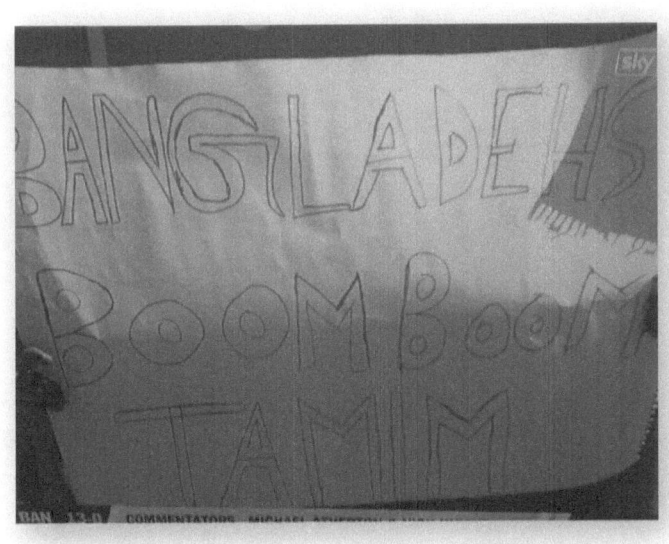
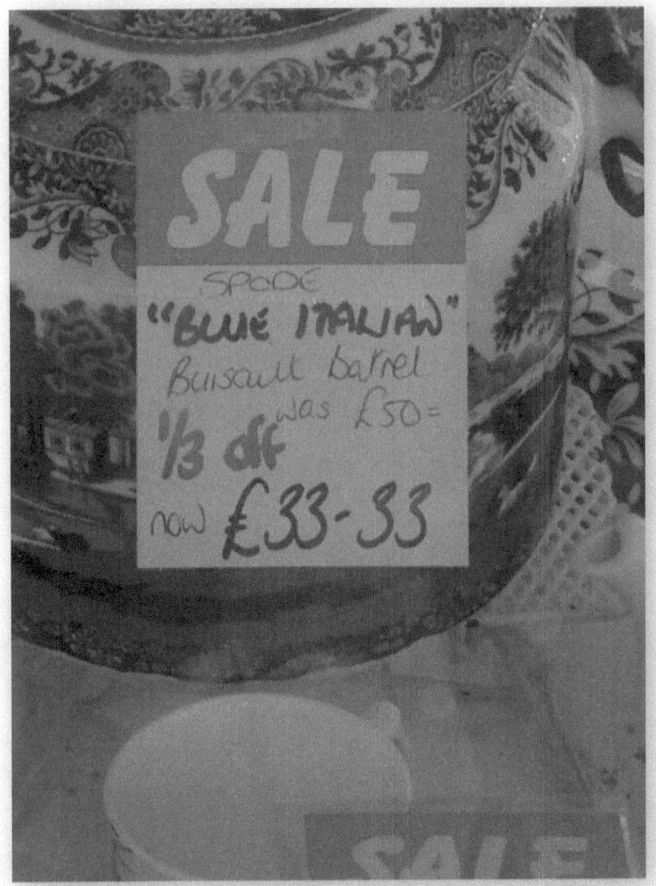

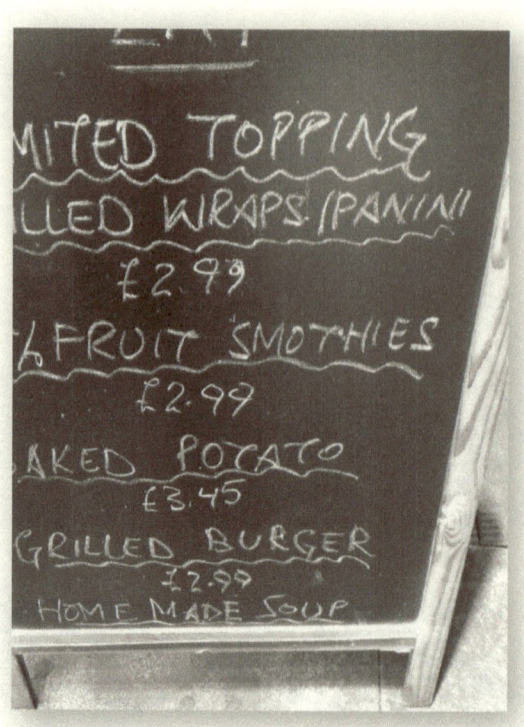

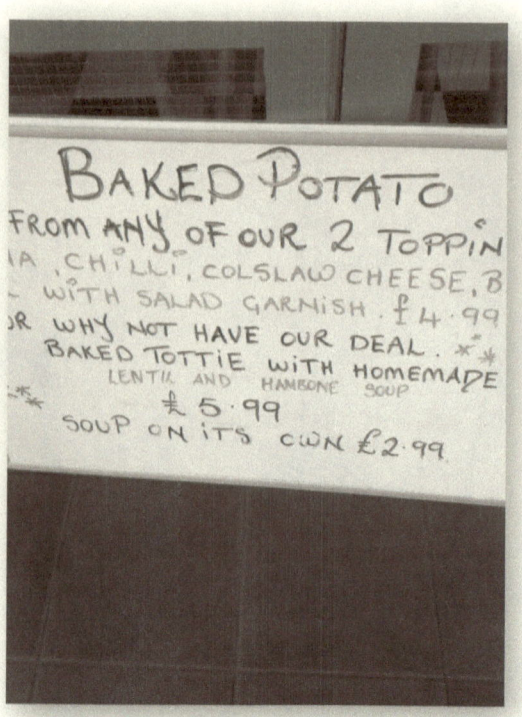

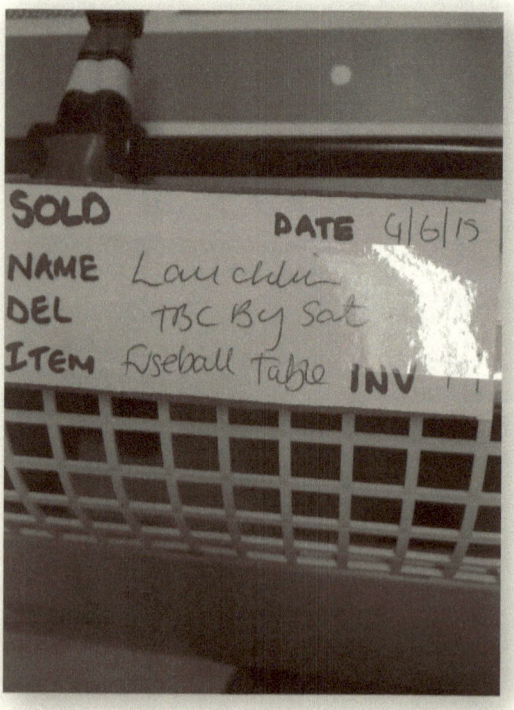

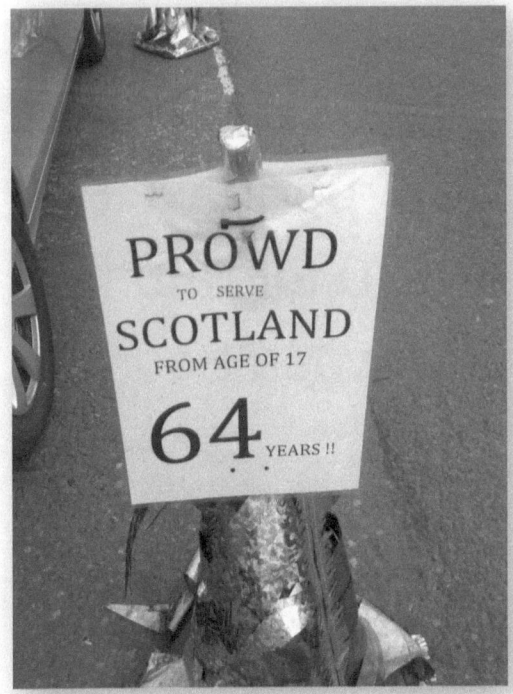

ease I can help

e airport taxi tra

£70 for retune

etween Bodrur

nium.

for you?.

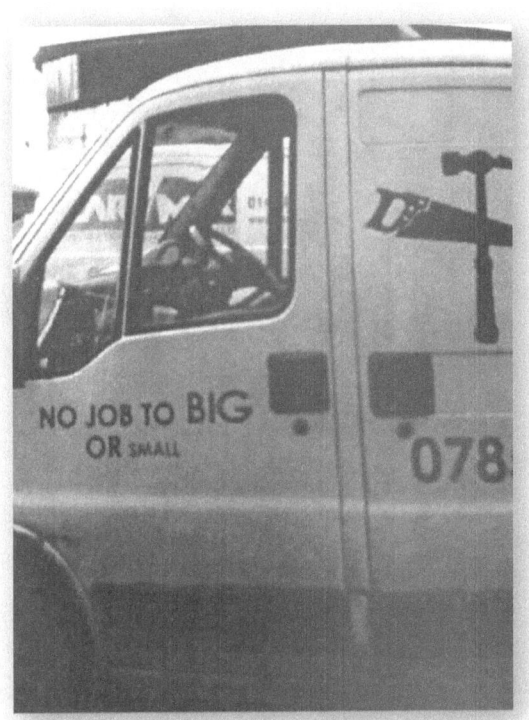

NO JOB TO BIG OR SMALL

---

**Nisa** — making a difference

CASH MACHINE CURRENTLY OUT OF ORDER

PLEASE USE OUR INSTORE POST OFFICE FOR FREE CASH WITHDRAWLS OR PURCHASES CAN BE PAID VIA CREDIT/DEBIT CARD CHECKOUTS

WE ARE SORRY FOR ANY INCONVENIENCE CAUSED

No unathorised vehicles allowed beyond this point

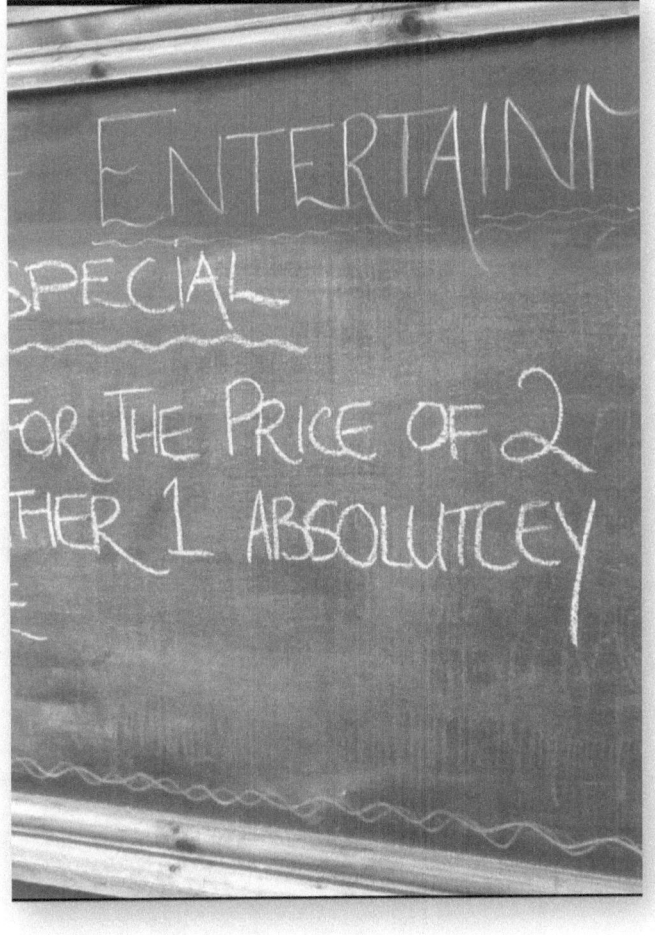

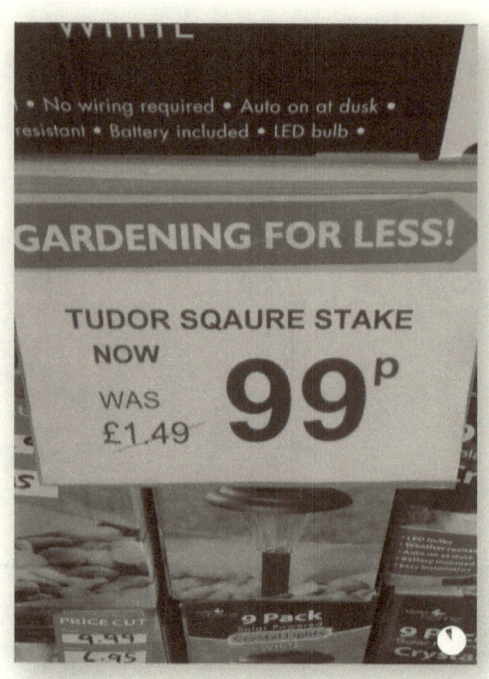

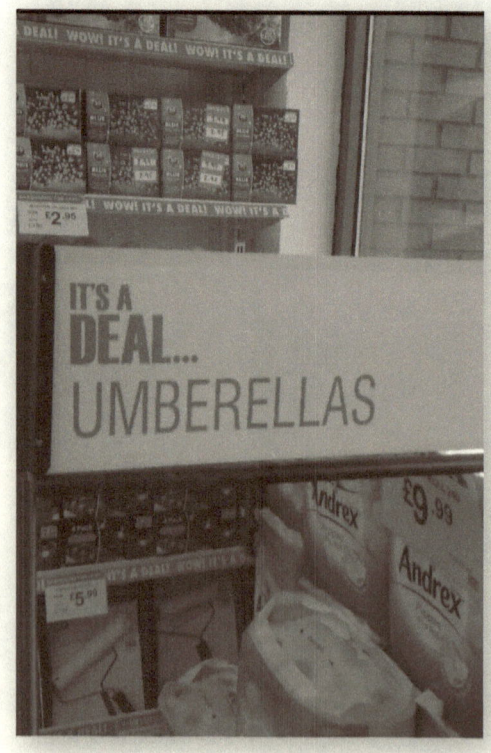

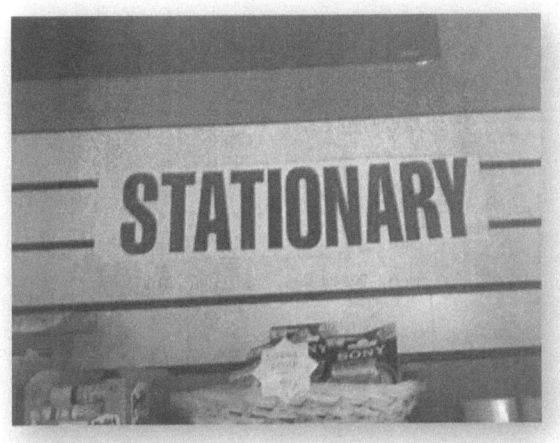

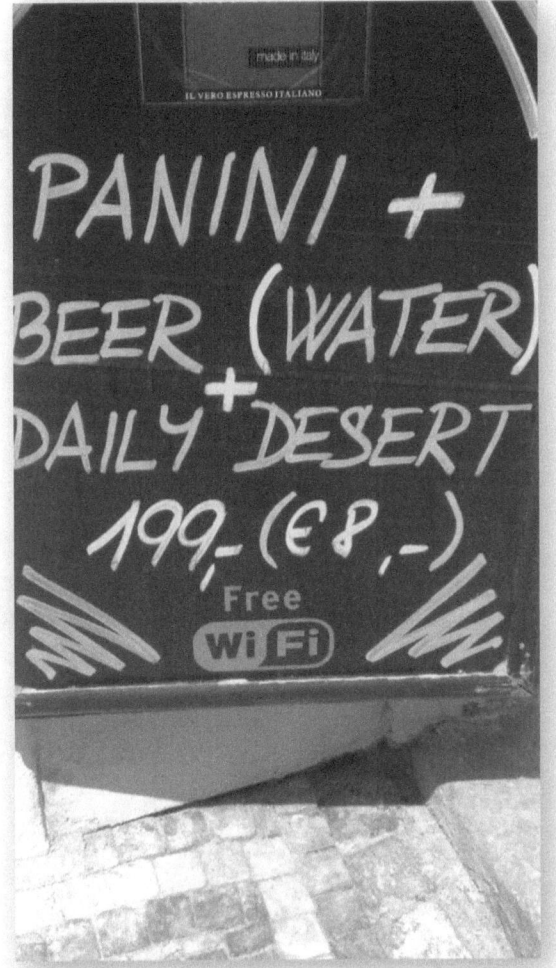

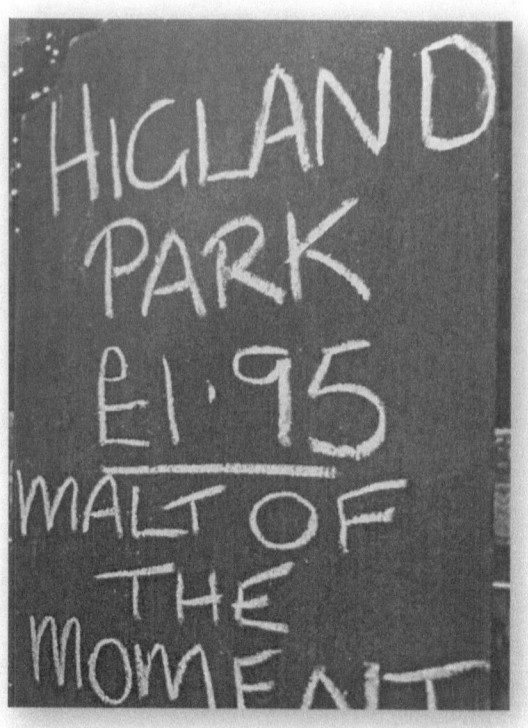

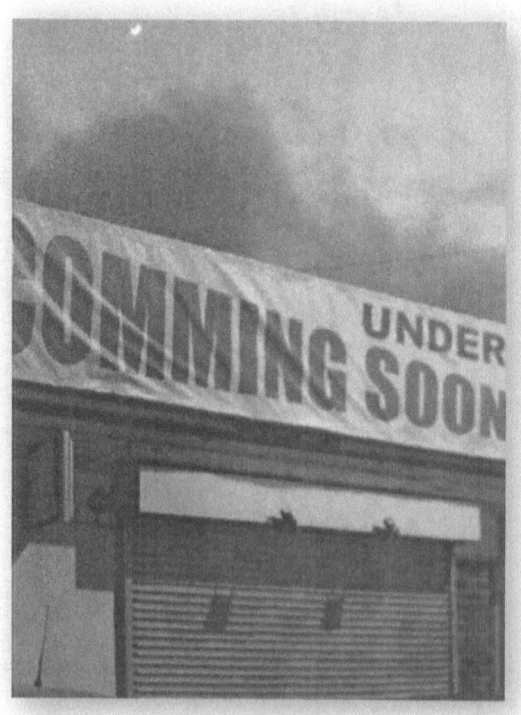

# BANNED IMAGES!!

## From Chapter 4 - Spelling...

I had a T.V.Screen-Grab of footballer Steven GERRARD going towards a young supporter to autograph a yellow Liverpool top for him... The replica top said GERARD on its back!!!

Another S.G. was a tennis match with the name of the umpire underneath + his designation in the match as..." UPMIRE"

A third sporting (football international) S.G. was "GIBRALTER v.LIECHTENSTEIN"

A joking one off of the Internet said that Glasgow Rangers had confirmed MR. BEAN as "THIER" new team manager!

# CHAPTER 5

# ONE WRONG, ONE RIGHT!!

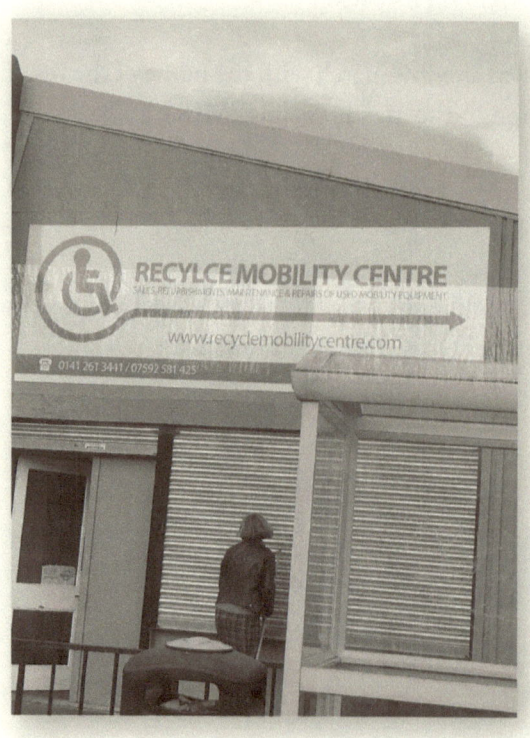

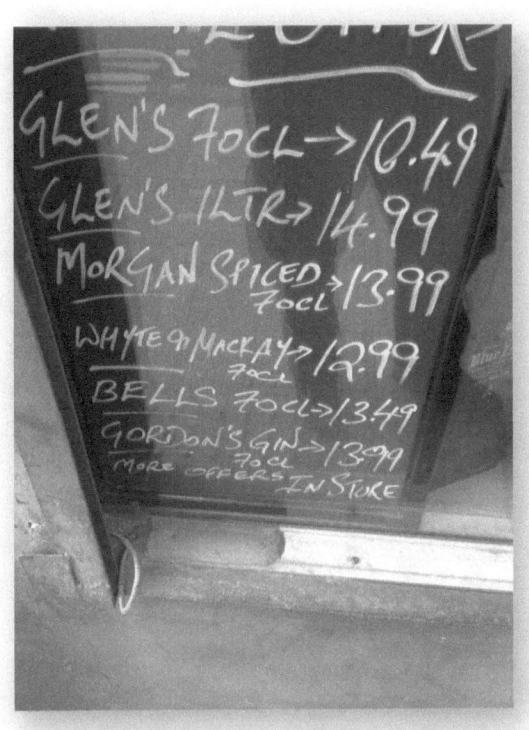

|  | 25ml |  |
|---|---|---|
| Gordon's Gin | 4.50 | Belvedere |
| Morgan's Spiced | 4.50 | Pernod |
| Famous Grouse | 4.50 | Baileys |
| Jack Daniel's | 4.60 | Cointreau |
| Smirnoff | 4.50 | Drambuie |
| Bacardi | 4.50 | Southern |

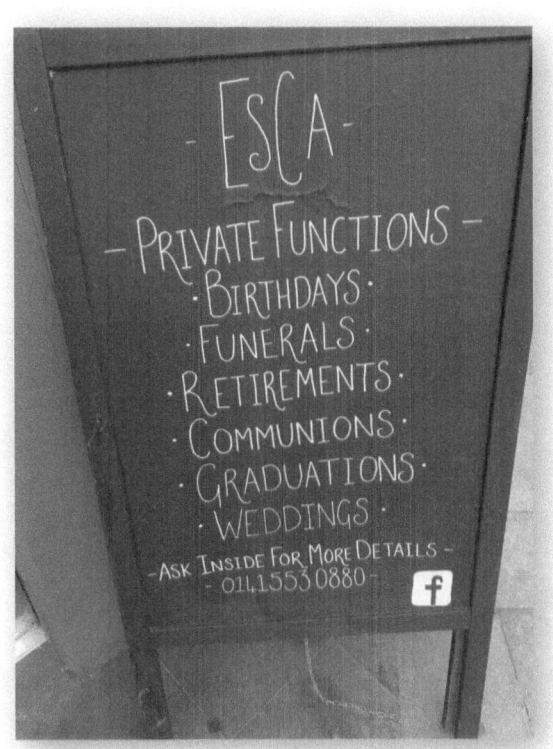
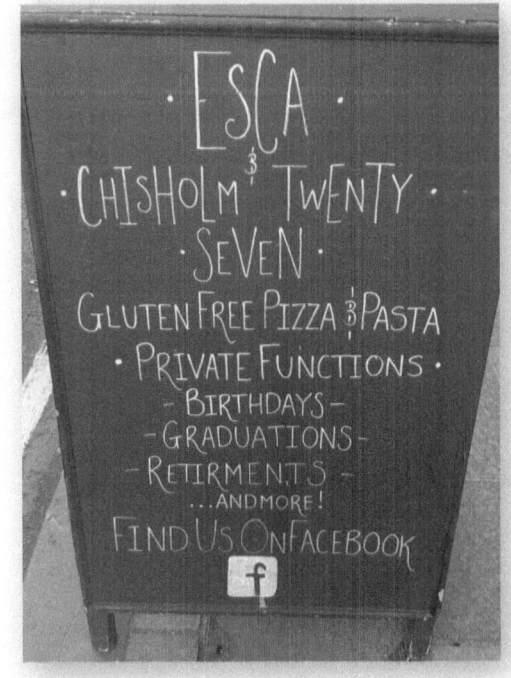

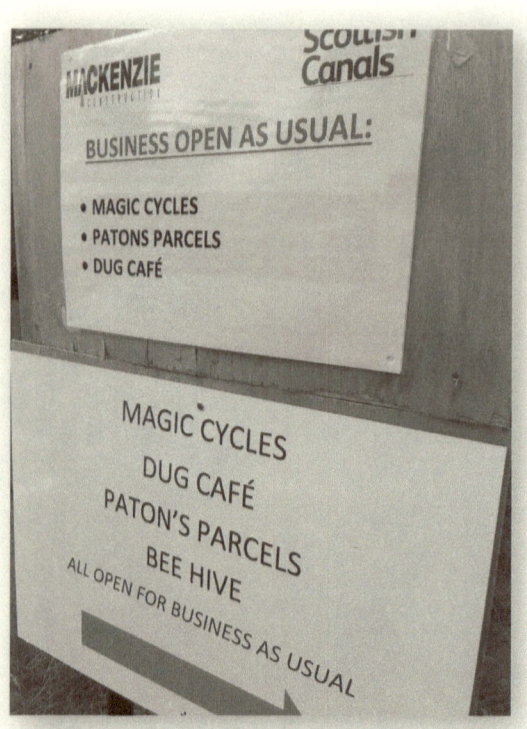

From the 'ONE WRONG, ONE RIGHT' Chapter I had an S.G. BANNED as it was taken from off of a T.V. advert, which was split in two...one half said PREMEIR LEAGUE, the other PREMIER!

## CHAPTER 6 AND 7

# T.V AND SUBTITLES

### Chapter 6 - T.V.
was 'BANNED' entirely as it consisted of 4 T.V. screen errors so all SCREEN-GRABBED!!!

All from off a T.V. series about words called "Catchphrase", one had an image of DOGS plus "EVERY DOG HAS IT'S DAY", a second one had an image of a book in a court witness stand but "DON'T JUDGE A BOOK BY IT'S COVER"

The third had an S.G. off of an advert about a fictitious Monster attack plus "IT'S VISION SEEMS TO BE..." and the fourth (all better with the images) was of off a DVD front cover for the programme with, wait for it... "THE NATIONS' FAVOURITE GAME SHOW" (I suppose we could argue over it, but U.K.programme = NATION'S to me!).

### Chapter 7 - SUBTITLES
was BANNED in its entirety, again, but not in WAp#6! So just lots of error-strewn errors off of T.V. captured off of my mobile phone cut in not to show T.V. channel or programme title but still a Banned by Law (!?!) Screen GRAB (is that in the dictionary now?!). Here they come...well the best of them...!

"A LOVELY MOMENT FOR JIMMY MERRY AND HIS BRAZILIAN PARTNER..." (think TENNIS!!!) ...

"IT'S SO CLEAR ITS UNBELIEVABLE"...

"SYRIA-TURKEY BOARDER"...

"A WIN TO STRENGHTEN THEIR RETURN TO THE TOP FLIGHT"...

"LIVE DUNDEED v DUNDEE UTD"...

"TYSON THEORY AGAINST DEONTE WILDER"...

"COPUTER VIRUS"...

"...A SECRET PASSAGE NONE OF US NEW ABOUT"...

"YOU WERE A SOLIDER"...

"NEW. THE BERNADETTE MANEUVER"...

"HAVE BEEN INSTRUCTED TO SHOOT ON SITE"...

"PITTSBURGH 17/2...ATLANTA 9/1... GREEN WAY 9/1"...

"A CALM PIANOAND VOILIN DUET"...

"SHOWERS LIKELY OVERNIGHT, SADDAM SPREADING EAST" (i.e.'SOME'!)...

"LIVERPOOL V ARESNAL"...

"AFTER HEATH SECRETARY JEREMY HUNT CALLED"...

"SPENDING TIME WITH OBESE PEOPLE IN YOUR LIFE"

(WORDS over a photograph of Borack and Michelle Obama - ergo THESE v. OBESE!!)...

"WEST INDIES AT EDBGASTON"...

"THE QUESTION ON EVERYONE'S'S LIPS"...

"WITH EVERY AMERICANS' FREEDOM AT STAKE"...

*Murray L. Peters*

## "MANAGER CARLO ANELOTTI"

SUBTITLES on all the time in our house due to my erm Ear Wax horror... Lots of literal IMAGE vital pieces not in here like a pic. of Beach Volleyball plus CYCLING in Subtitles and then Cyclists with Beach Volleyball!!

# CHAPTER 8
# SOFIA 2017

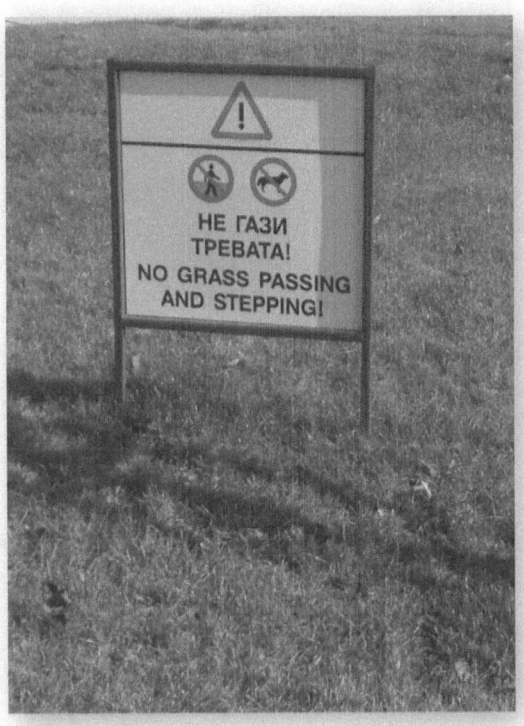

## CHAPTER 9

# FUENGIROLA 2018

Croissant mixto de jamó
Mixed croissant with ha
Zumo naranja natural /

*Smothies*  | CON LE
            | WITH
            | o / o
            | CON ZU
            | WITH J

**TROPICAL** (Piña, mango,
**COCO MANGO** (Mango,
**FRESA / STRAWBERRY**
**VITALIGHT** (Naranja, piñ
**ULTRA VIOLET** (Fresa, blueberry)

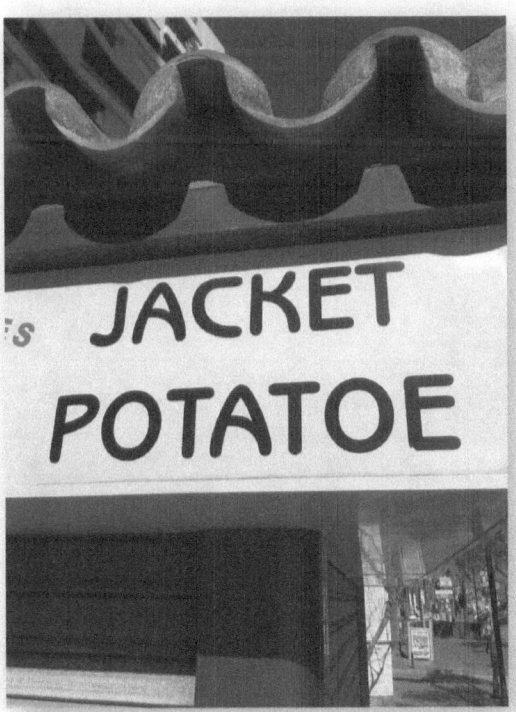

JACKET POTATOE

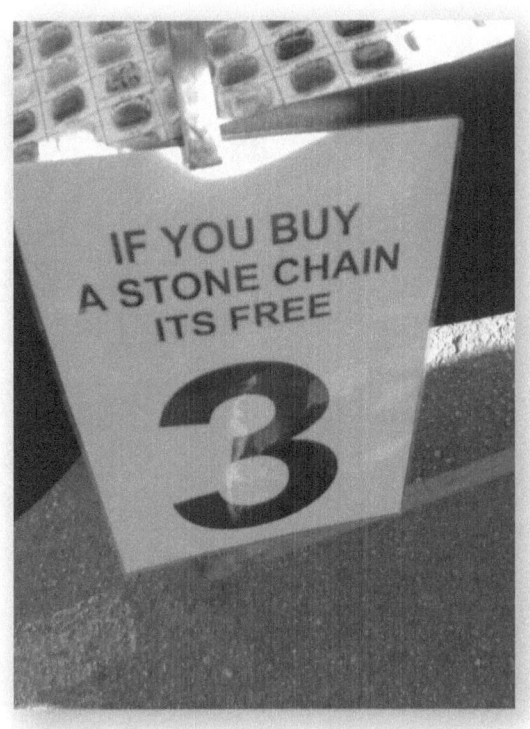

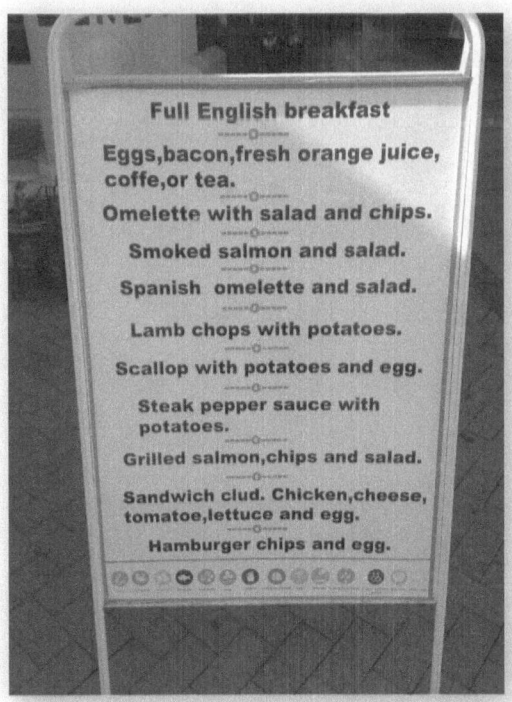

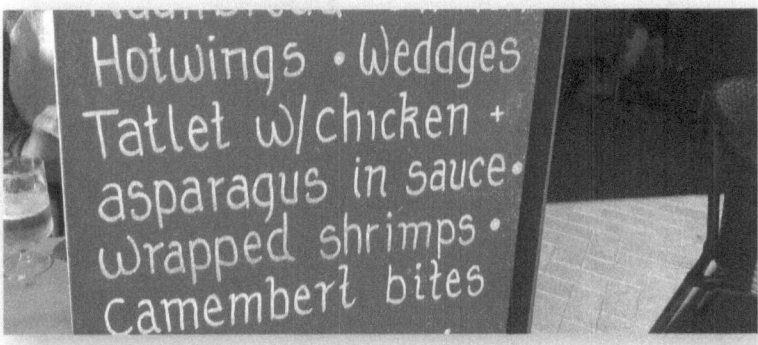

# CHAPTER 10
# JUST WEIRD

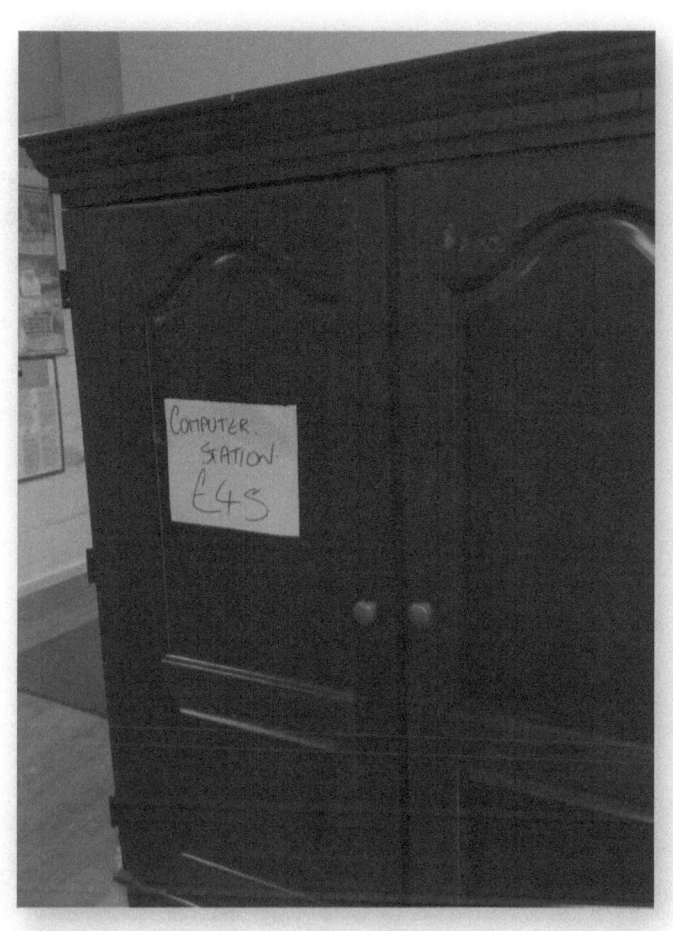

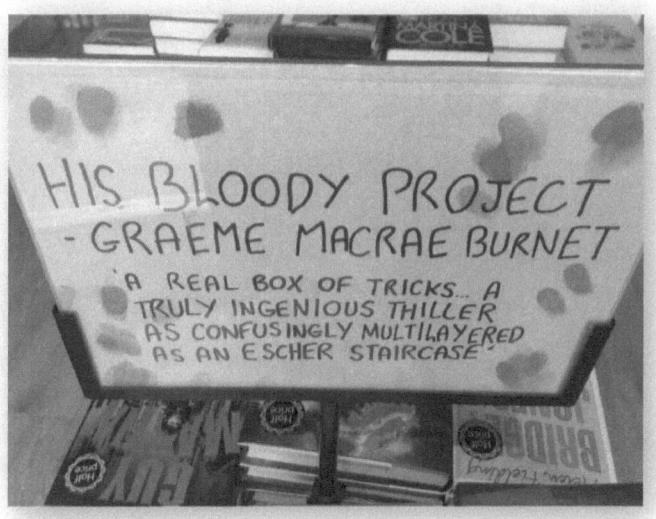

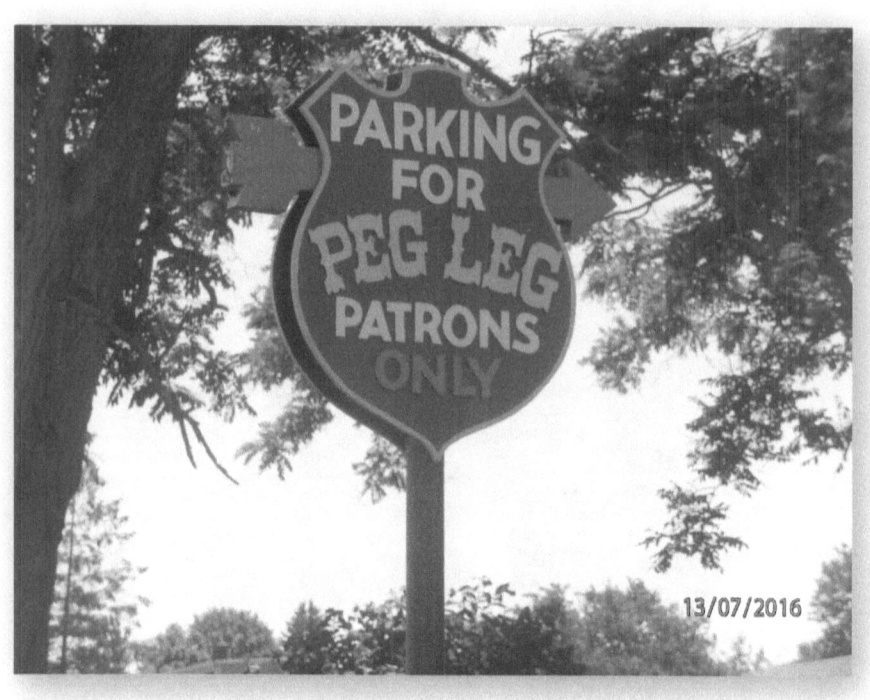

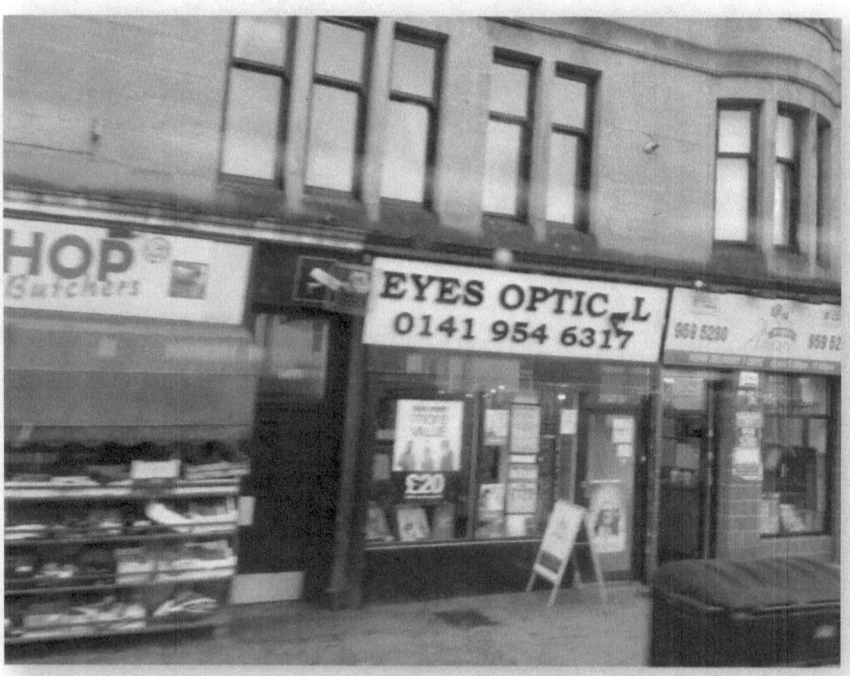

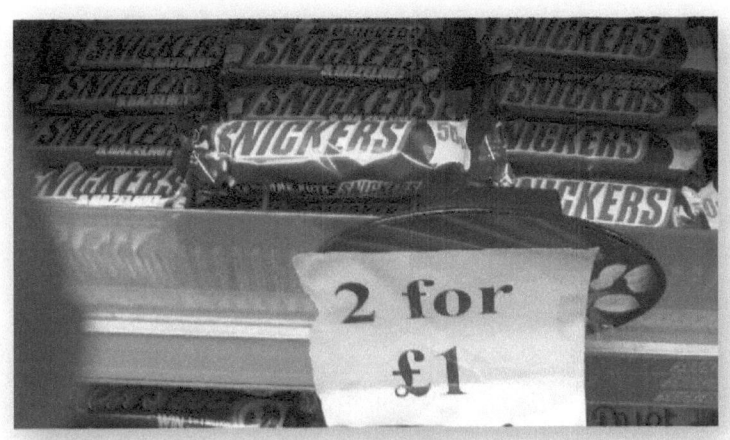

**Football this week**

**Tuesday 28ᵗʰ**
Rangers vs st Johnston 7.30

**Wednesday 29ᵗʰ**
Man city vs Newcastle 7.30

**Friday 31ˢᵗ**
St Johnston vs Motherwell 7.30

**Saturday 1ˢᵗ**
Newcastle vs Liverpool 12.30
Bayern munich vs borussia 5.30

**Sunday 2ⁿᵈ**
Man city vs man utd 1.30
Villa vs Tottenham 400

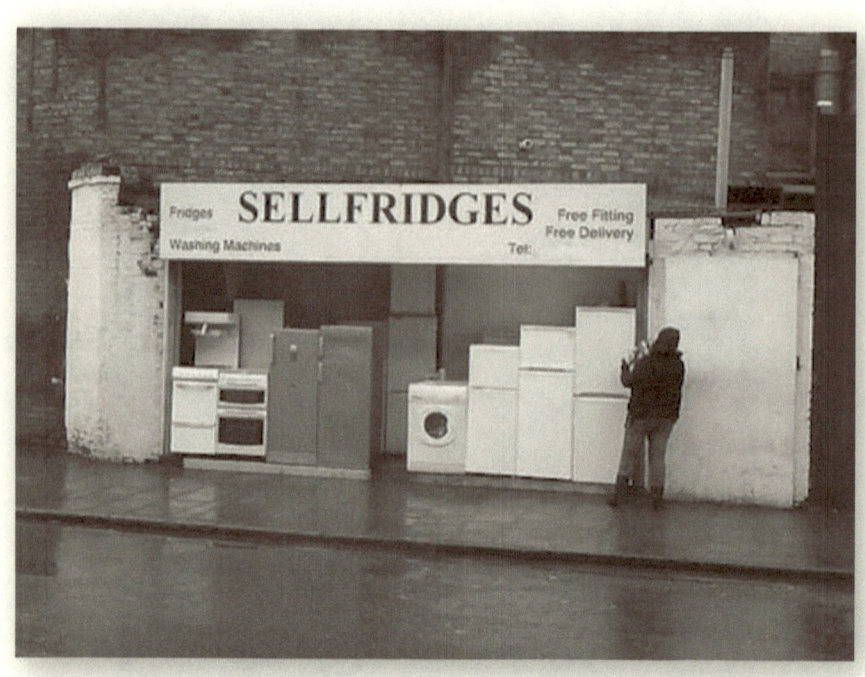

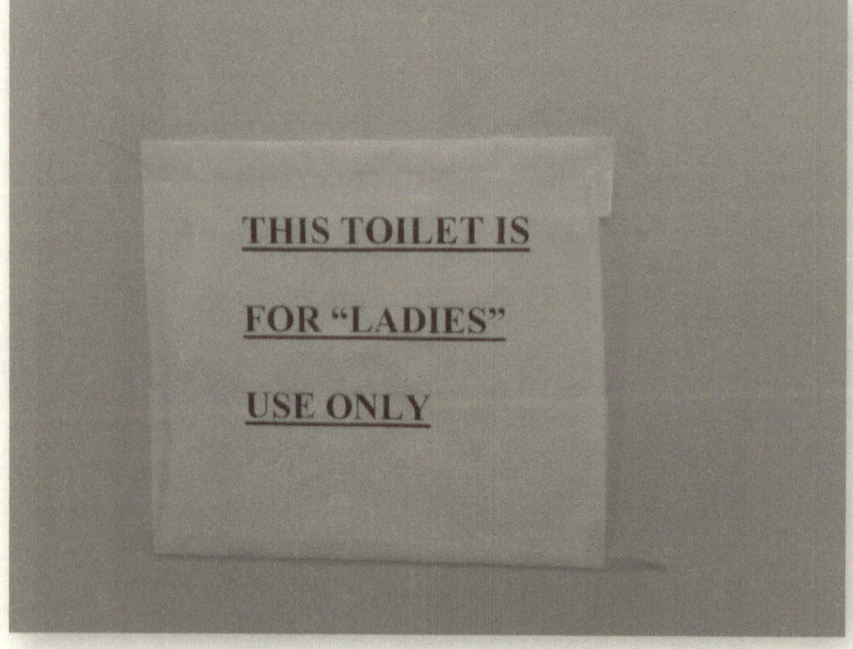

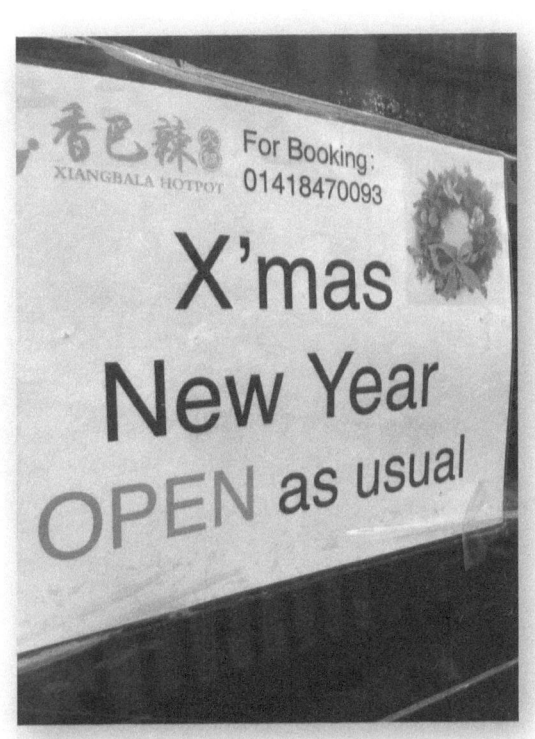

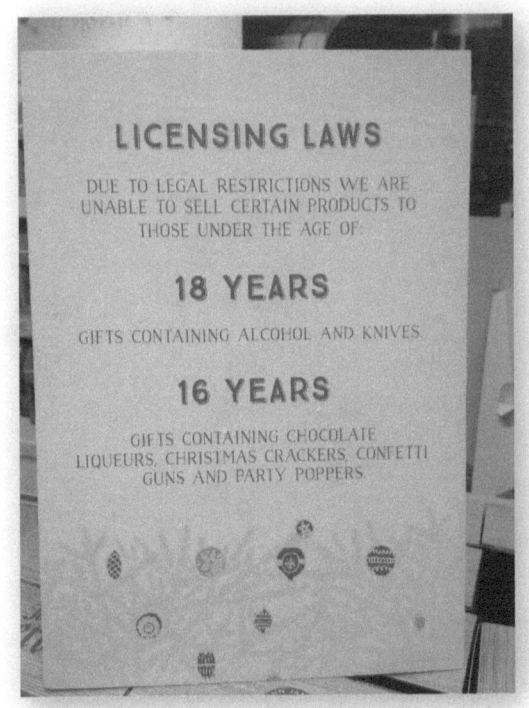

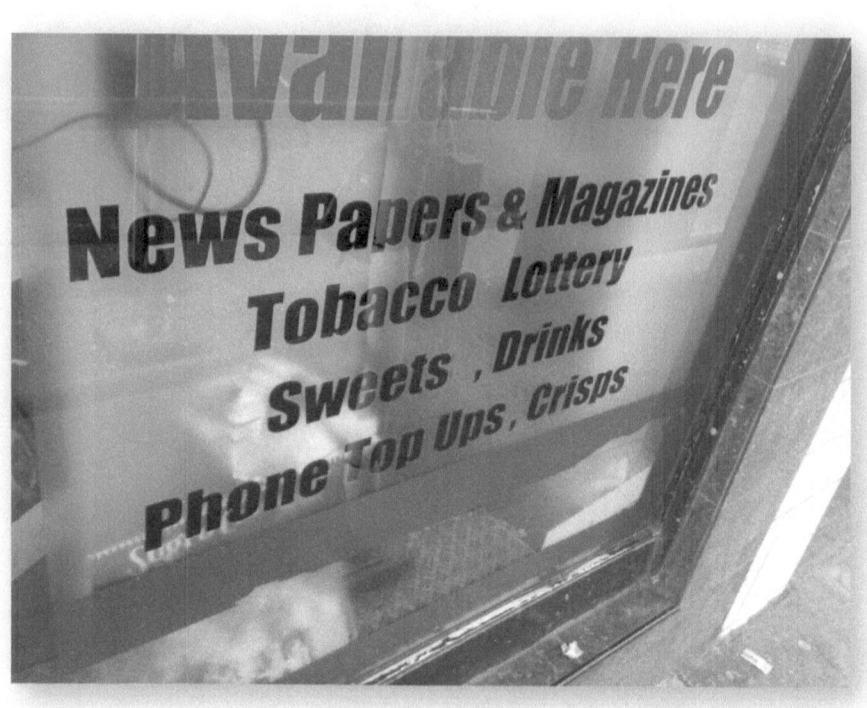

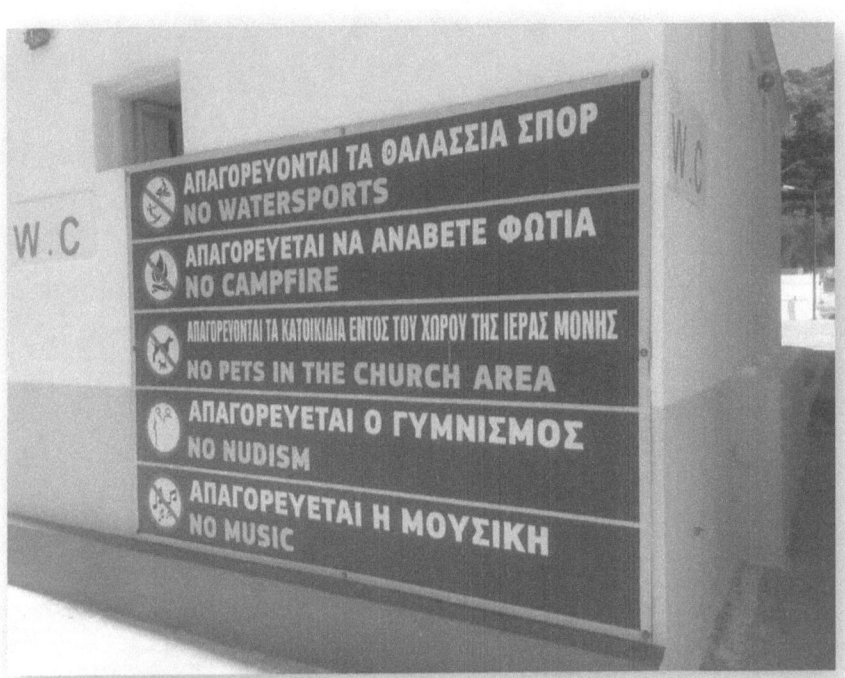

# NEW MENU

...e just launched our new Summer menu.

...o get that bikini body before your holiday
...e a wide range of salads, pastas and snac...
... suitable for alot of healthy eating clubs.

...ow know, many coeliacs think that they
...or dinner......think again! We have a glut...
...ction in our main and dessert menus.

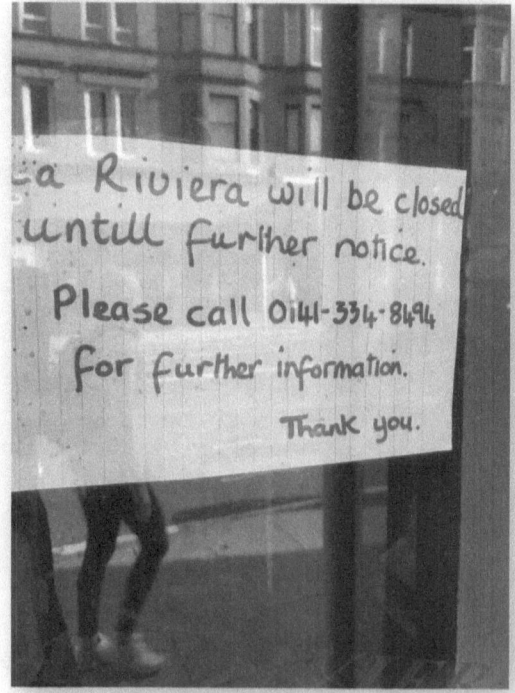

...a Riviera will be closed
...untill further notice.
Please call 0141-334-8494
for further information.
Thank you.

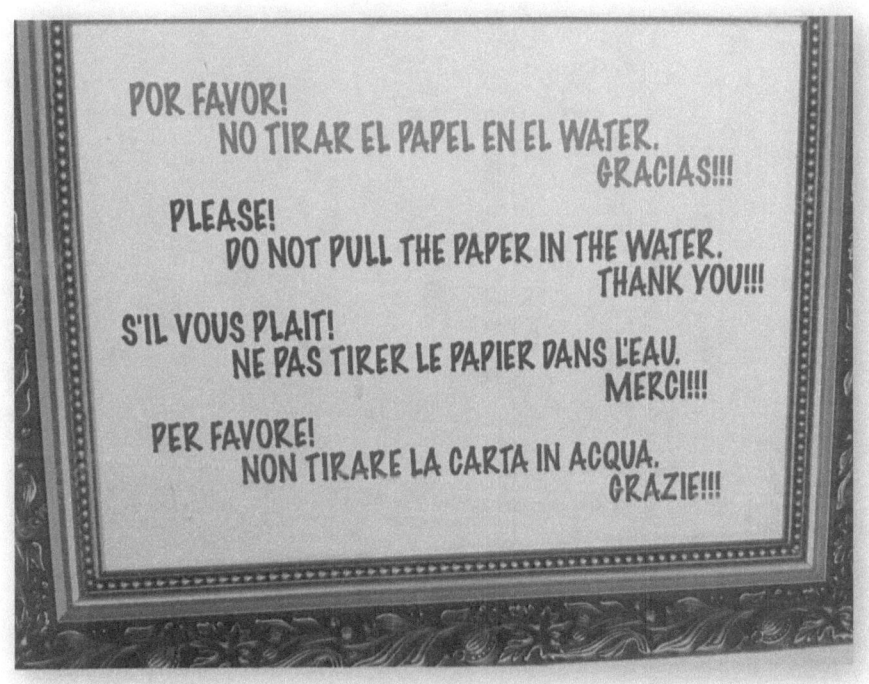

# CHAPTER 11
# MLP

www.ingramcontent.com/pod-product-compliance
Lightning Source LLC
Chambersburg PA
CBHW030755180526
45163CB00003B/1028